3DTOTAL PUBLISHING

Correspondence: publishing@3dtotal.com
Website: www.3dtotal.com

Every effort has been made to ensure the credits and contact information listed are present and correct. In the case of any errors that have occurred, the publisher respectfully directs readers to the **www.3dtotalpublishing.com** website for any updated information and/or corrections.

First published in the United Kingdom, 2015, by 3dtotal Publishing. 3dtotal.com Ltd, 29 Foregate Street, Worcester WR1 1DS, United Kingdom.

Soft cover ISBN: 978-1-909414-26-6
Printing and binding: Everbest Printing (China)
www.everbest.com

Visit **www.3dtotalpublishing.com** for a complete list of available book titles.

Editor: Marisa Lewis
Proofreader: Melanie Smith
Lead designer: Imogen Williams
Cover designer: Matthew Lewis
Designer: Aryan Pishneshin
Managing editor: Simon Morse
Non-attributed artwork: Marisa Lewis

HOW TO KEEP A
SKETCH
JOURNAL

3DTOTAL**PUBLISHING**

CONTENTS

HOW TO KEEP A

SKETCH
Journal

3dtotal publishing

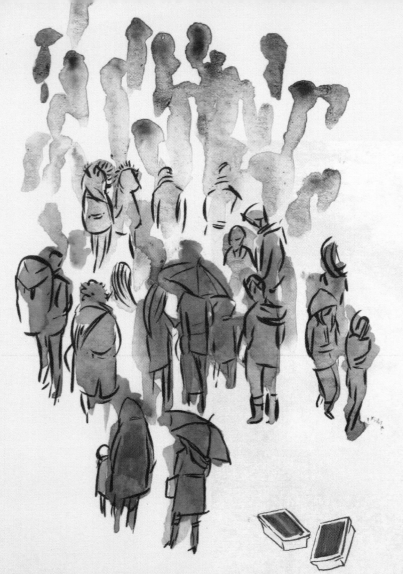

INTRODUCTION

"Once something's been drawn or
noticed, it's never forgotten - a sketch
journal is a perfect personal diary"

Florian Afflerbach

Sketching is one of many ways for a visually minded person to record their life and surroundings. Whether you draw for a living or just for fun, or are picking up a pencil for the first time, keeping a sketch journal is a valuable habit that will change the way you observe the world and document your memories.

You have to just *go for it*, but we know that can be easier said than done when you're trying to find your feet with different techniques, ideas, and ways of looking at the world. To help motivate you on your sketch journal journey, we've created this book to show you some of the many ways sketching can be approached. From simple pencil drawings, to watercolors and inks, to cut-outs and collage, we take a look inside the minds and journals of eight talented artists who have been kind enough to share their techniques with us.

We hope you find this book educational, inspiring, and fun, and come away with some great ideas for your own journal!

Marisa Lewis
Editor
3dtotal Publishing

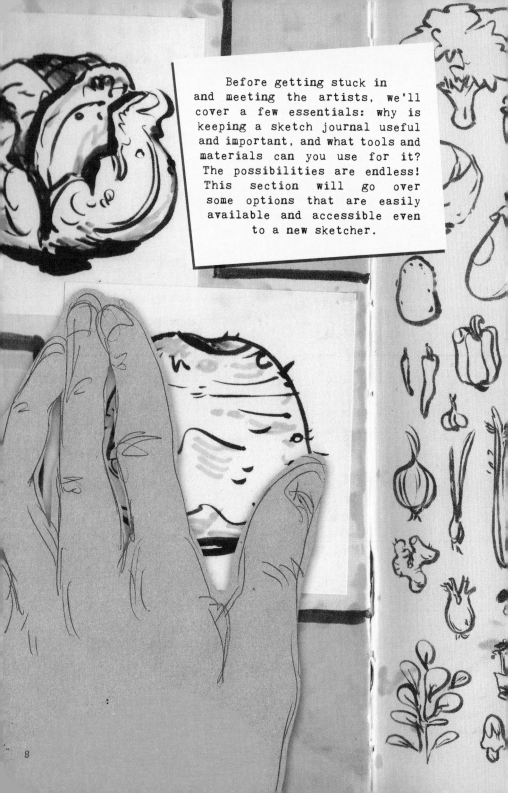

Before getting stuck in and meeting the artists, we'll cover a few essentials: why is keeping a sketch journal useful and important, and what tools and materials can you use for it? The possibilities are endless! This section will go over some options that are easily available and accessible even to a new sketcher.

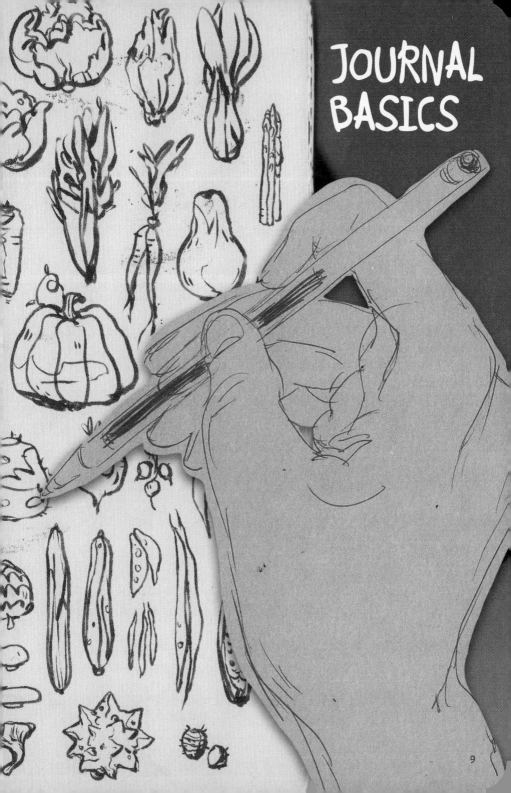

JOURNAL BASICS

WHY KEEP A SKETCH JOURNAL?

TO PRACTICE YOUR SKILLS

Drawing from your surroundings is always useful. Whether you're waiting in a café or bored on the train, you can always find a moment to jot down something interesting.

TO HELP YOUR CREATIVE CONFIDENCE

Your journal is a private space for you to flex your artistic muscles and reflect on your progress. Nobody else has to see it if you don't want them to. It doesn't have to look good or make sense to others!

TO RECORD YOUR THOUGHTS AND IDEAS

If you keep a journal, you'll always have an archive of material to refer back to. Whether it's a stroke of genius or just something silly, you never know when those ideas might come in handy and inspire something bigger.

TO EXPERIMENT WITH DIFFERENT TECHNIQUES

Your journal is an open-ended project where you shouldn't feel tied down to making perfect artwork or working in a particular way. If a technique or medium catches your eye, try it out, whether it's for a day or for month!

TO MAKE A DOCUMENT OF YOUR ENVIRONMENT

Your sketch journal can also serve as a travelogue or diary of your surroundings. It's different to taking a photo; you'll really remember your place in the scene when you look at the drawing again.

To keep your mind (and hands) busy

Your journal can be therapeutic. If you're clamoring with ideas, it's a place you can get them out. If you're creatively tired and need to switch off, it's a place to unwind.

TOOLS AND MATERIALS

You can keep a sketch journal in dozens of ways, whether you use a whole box of tools or just a simple pencil. Here are some of the tools and materials that you could try.

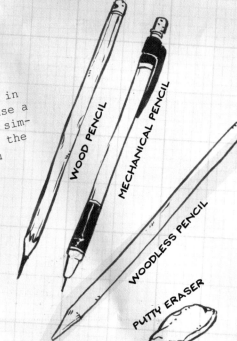

WOOD PENCIL

MECHANICAL PENCIL

WOODLESS PENCIL

PUTTY ERASER

PENCILS

GRAPHITE PENCILS

are humble but not to be underestimated! Pencils can be wooded or woodless, and can be sharpened with a pencil sharpener or artist's knife. A mechanical pencil doesn't even need sharpening!

Pencils are measured in H and B grades. A high B grade (2B to 9B) means the graphite is very black, soft, and smudgy. A high H grade (2H to 9H) means it's hard and compact, making lighter, finer marks. The versatile HB falls near the middle of the scale and is the most common grade you'll find.

COLORED PENCILS are

an easy way to spice up your sketch pages. A white pencil is great for adding highlights to toned paper.

WATERCOLOR PENCILS can be

blended with water and are easier to control than paints, ideal if you're still getting to grips with using a brush and water. Try mixing dry colors together before adding water, or draw straight onto a slightly damp paper.

PASTEL and CHARCOAL PENCILS

are useful for trying different effects without getting your hands dirty as you would with a pastel or charcoal stick.

ERASERS are often

plastic or rubber, which are durable but create rubbings and can crumple your paper if you're not careful. Putty erasers are more suitable for artists: they don't create rubbings and can be squashed into a point for erasing fine details or highlights.

BALLPOINT PEN. A versatile pen that you'll certainly have in the home or office. They're easy to sketch and doodle with, but will bleed if used with anything damp. Ballpoint drawings can also fade or discolor after a few years, but these pens are still great for a quick fix.

PENS

FINELINER. These pens are made especially for drawing, available in different thicknesses that offer a lot of control over your lines. It's best to get pens with waterproof and lightfast ink, so your drawings won't bleed or fade.

FOUNTAIN PEN. A nib pen for writing or drawing, with its own reservoir of ink inside (usually a replaceable cartridge). Fountain pens usually use water-based ink so be careful using them with other wet media. Waterproof ink can clog a fountain pen's inner workings.

DIP PEN

BALLPOINT PEN

FINELINER

MARKER PEN

BRUSH PEN

DIP PEN. The older brother of the fountain pen, consisting of a handle and replaceable nib that needs to be dipped or loaded with ink first. It is usable with many types of ink, which will often come with a pipette to help you apply ink to the nib.

MARKER PEN. Great for bold colors and big shadows! Felt pens and Sharpies are useful for filling space, but can discolor over time. Alcohol-based pens like Copic and Prismacolor markers are expensive but long-lived and perfect for blending smooth layers of color.

Watercolors

Watercolors are the most affordable type of paint and don't need many tools to use. Perfect for sketching and traveling with! They are available as tubes of thick liquid paint or in small dry cakes called pans or half-pans.

FAN BRUSH

ROUND BRUSH

RIGGER BRUSH

SQUARE BRUSH

MOP BRUSH

WATERBRUSH

Some common types of brush are shown here. If you're traveling or sketching on the go, a waterbrush is a clever solution: a brush-tipped pen that has a built-in reservoir for water!

Watercolor does sometimes get where you don't want it to, so for more detailed work, you can use masking fluid to protect areas of the paper. Once the paint has dried, you can peel off the masking fluid to reveal the original paper color.

Don't forget to carry some tissue or kitchen roll to clean your brushes and blot excess paint!

PASTELS, CRAYONS, AND STICKS

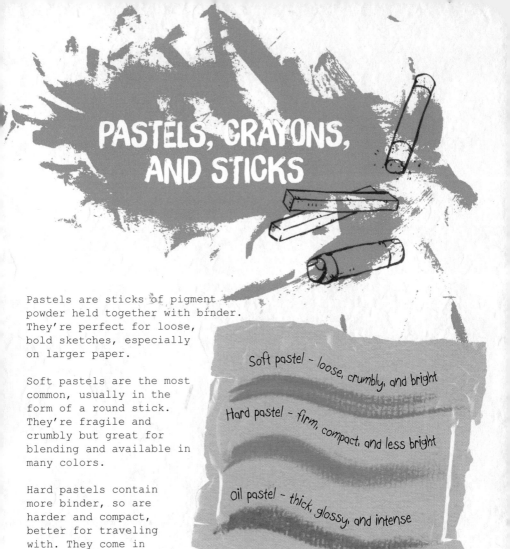

Pastels are sticks of pigment powder held together with binder. They're perfect for loose, bold sketches, especially on larger paper.

Soft pastels are the most common, usually in the form of a round stick. They're fragile and crumbly but great for blending and available in many colors.

Hard pastels contain more binder, so are harder and compact, better for traveling with. They come in square sticks which make it easier to draw fine lines.

Soft pastel – loose, crumbly, and bright

Hard pastel – firm, compact, and less bright

Oil pastel – thick, glossy, and intense

Oil pastels have a thick, glossy finish which is hard to blend, but they don't crumble and can be layered like oil paints!

Conté crayons or sticks are similar to hard pastels, but are made with graphite or charcoal. They are typically available in a limited range of naturalistic colors: black, white, gray, and brown tones.

You can sketch on any kind of paper. Don't feel limited to expensive brands when envelopes and sticky notes can be just as fun! That said, here are some common types of art paper. Most paper is acid-free so it doesn't get damaged by age. Its weight is measured in gsm (grams per square meter) or lbs. If you're using media like watercolor, inks, and pastels, it becomes more important to use paper that's heavy enough.

Rough paper is
less processed, with an even heavier tooth than cold press paper. It's less suited for detailed work, as the surface can be too coarse, but it's great for loose, textured work with watercolor or pastels.

Cold press watercolor paper
(or 'NOT' paper, as in 'not hot') has more tooth, or surface texture, than hot press. This means paint dries quickly and is absorbed faster. Cold press paper is a common choice for watercolors.

Hot press watercolor paper is pressed by a hot machine when it's made, creating a smooth surface. It's great for combining watercolors with drawing tools like pen or pencil. Paint takes longer to dry as the water sits on the smooth surface, allowing you to blend and bleed colors easily.

Cartridge paper is
smooth, heavy paper ideal for pen or ink.

Pastel paper has a slight texture so
pastels can adhere easily. It's often gray, brown, or other darker colors so the pastels stand out.

OTHER BITS AND BOBS

The materials you use in your journal don't have to be limited to what you can buy from an art shop. Try keeping **FOUND OBJECTS**' and sticking them into your journal — **TRAIN TICKETS** from somewhere you traveled, buttons and coins, stickers and stamps, it could be anything! Cut up magazines and newspapers, or other interesting **PAPERS AND TEXTURES**. Make your own drawing implements — how about using a twig or feather instead of a pen or brush?

EXPERIMENTATION IS KEY TO FINDING THE MATERIALS AND TECHNIQUES THAT SUIT YOU. LET'S MEET SOME ARTISTS AND SEE WHAT TOOLS AND MATERIALS THEY USE FOR THEIR JOURNAL-KEEPING...

FLORIAN AFFLERBACH

flaf.de

I'm from Siegen, Germany. I'm an assistant professor at the Universities of Siegen and Dortmund for spatial design and architectural drawing.

WHY DO YOU KEEP A SKETCH JOURNAL?

I always carry at least one sketchbook with me. I fill them with a mixture of written thoughts, architectural design sketches, urban sketches and to-do lists. They help me to handle my daily routine and keep things in mind better.

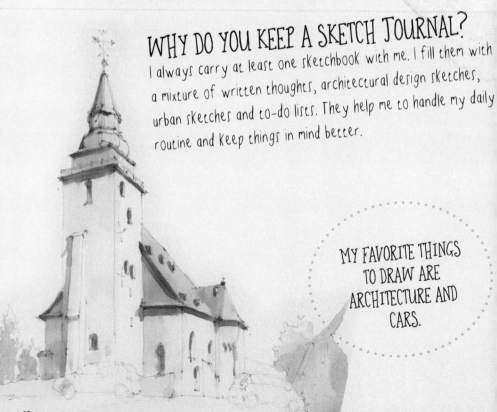

MY FAVORITE THINGS TO DRAW ARE ARCHITECTURE AND CARS.

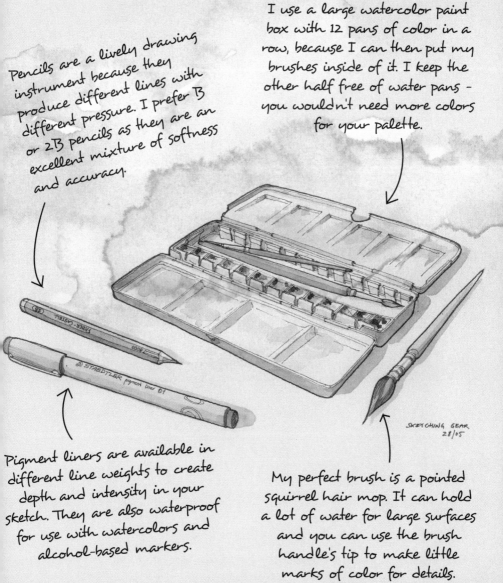

Pencils are a lively drawing instrument because they produce different lines with different pressure. I prefer B or 2B pencils as they are an excellent mixture of softness and accuracy.

I use a large watercolor paint box with 12 pans of color in a row, because I can then put my brushes inside of it. I keep the other half free of water pans - you wouldn't need more colors for your palette.

SKETCHING GEAR
28/05

Pigment liners are available in different line weights to create depth and intensity in your sketch. They are also waterproof for use with watercolors and alcohol-based markers.

My perfect brush is a pointed squirrel hair mop. It can hold a lot of water for large surfaces and you can use the brush handle's tip to make little marks of color for details.

SHADING BUILDINGS WITH PENCIL

2B pencil

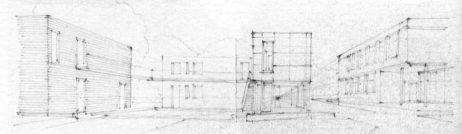

1 I do the initial drawing as an outline, showing all the volumes of the space, including the foreground, middle ground (buildings), and background (trees). The view is in one-point perspective with a central vanishing point. I've already added some structure, such as the wood panels of the left cube and jagged outline of the trees in the background.

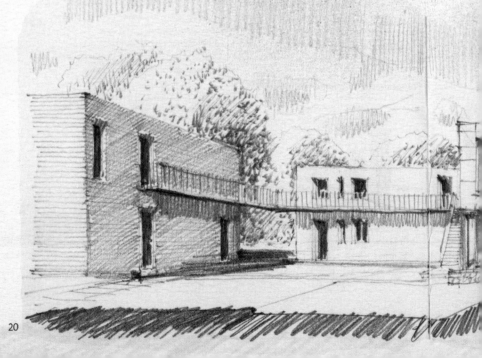

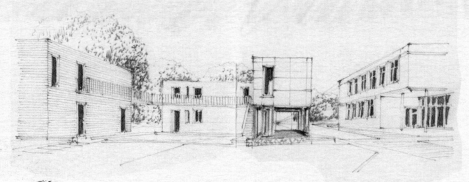

2 I add value to the building's openings. Glass surfaces are usually dark during the day, so they can be hatched with strong pencil lines. The glass base of the central building here should have a certain transparency. I use the direction of the sunlight to give leaf structure to the trees – the darkest areas are on the reverse side of the sunlight.

PRO TIP

Don't draw with too-hard pencils! An HB should be the hardest in your sketching gear. A soft pencil is versatile for thin and bold lines, so try to achieve a certain mastery of this instrument during one drawing.

3 I locate all the shadows that the sun creates on the buildings. Don't forget to differ a building's own shadow from its cast shadow – it's usually a lot darker. I do the buildings' own shadows with diagonal hatching (see the left building) and the cast shadow with vertical lines (see the bridge) or lines going towards the vanishing point (see bottom shadow of the left cube). Respect the atmospheric principles and give foreground shadows more intensity than background shadows.

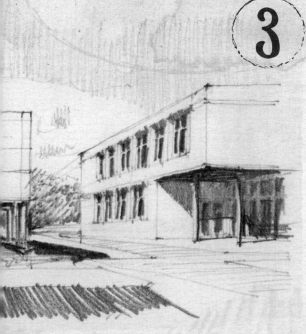

PEN WITH ALCOHOL-BASED MARKERS

→ 0.05 AND 0.3 PIGMENT LINERS, DIFFERENT GRAY TONES OF ALCOHOL-BASED MARKERS

1 I do this drawing with a 0.05 pigment liner. The thicker outline (0.3 pigment liner) is not necessary, but it gives the drawing a certain border and underlines its position on the page.

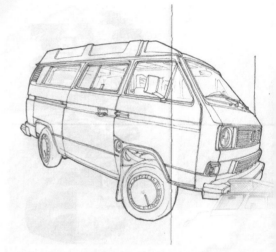

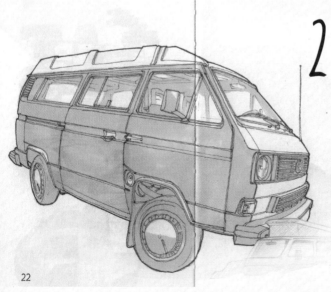

2 Locate the direction of the light first. Choose the lightest gray marker you have, then fill everywhere on the drawing of the bus. Leave out white spaces like the roof cabin, light reflections, and the view through the windows. Try to work fast, as markers dry quickly.

3 The next gray marker should be a little darker than the first one. Use it where you want shadows, dark reflections, and black car details (for example radiator grill, rear view mirror, wheels). If the marker is double-ended, use the fine end for details. This step can be increased with another gray marker which is again a little darker.

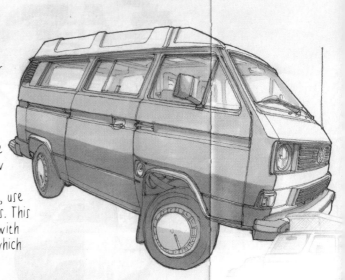

PRO TIP

MARKERS ARE A PERFECT DRAWING INSTRUMENT FOR MODELING, TO LET THINGS APPEAR VERY PHYSICAL. THEY'RE VERY USEFUL BUT NOT VERY LOW-PRICED, SO IT'S BEST IF YOU PICK A RANGE OF GRAYS AT FIRST, FROM VERY LIGHT TO NEARLY BLACK. AFTER AN ADJUSTMENT PERIOD, YOU CAN ADD SEVERAL LIGHT COLORS TO YOUR COLLECTION.

WESTFALIA

4 The last two gray tones slowly approach black. Use them consecutively for shaded zones (like the wheel arches and door seals). They are only for small parts of the drawing, so use them purposefully. The 'WESTFALIA' lettering was stuck on the reverse side of the bus - sometimes it's cool to collect additional information of the drawing subject for journaling!

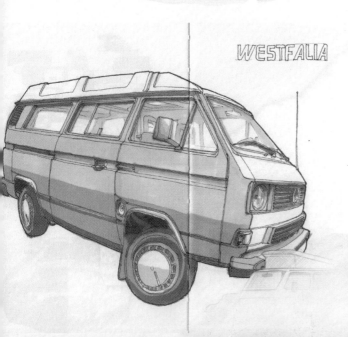

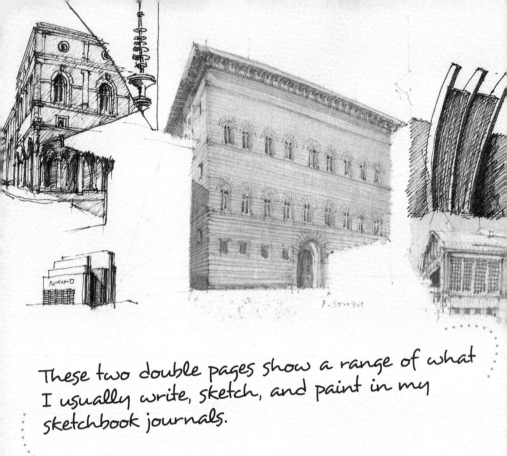

These two double pages show a range of what
I usually write, sketch, and paint in my
sketchbook journals.

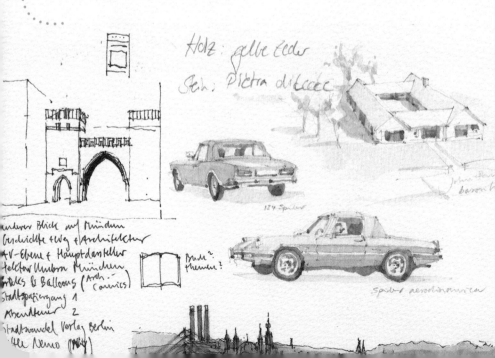

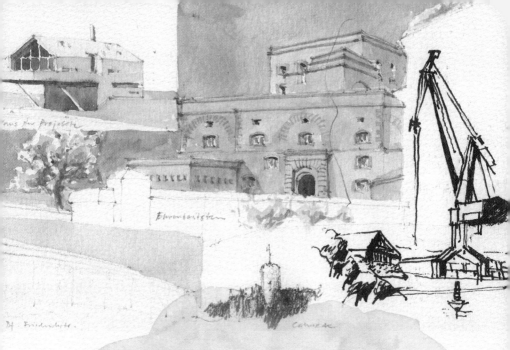

You can see design projects I was actually inspired by, hand-written notices, a panoramic view done from the train, vintage cars on the street during my lunch break, and little watercolor drawings from trips to the river Rhine, Berlin, Hamburg, and Florence. I used mostly pen or pencil with watercolor.

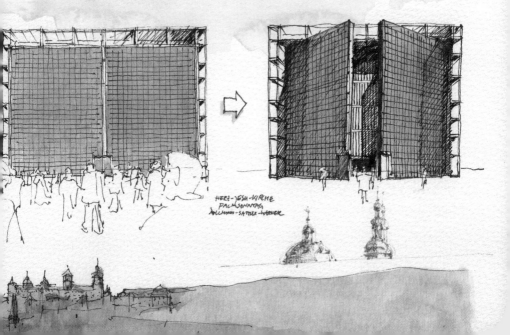

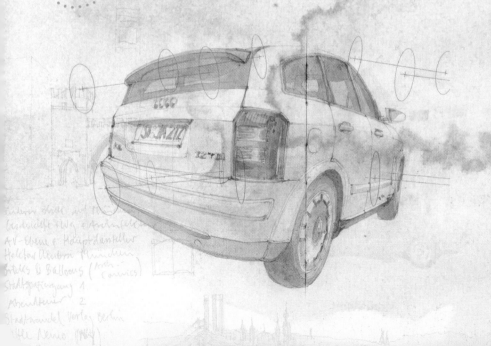

WHAT ADVICE WOULD YOU GIVE TO SOMEONE WHO'S JUST GETTING INTO SKETCHING?

Sketch as much as you can, from direct observation or from your imagination. The only limit for your inspiration is your personal interest in the subject. Use different types of drawings (such as infographics, details, cross-sections, perspectives, or other analytic drawings) to really get behind things. Be critical with yourself and always have a look at other sketchers' works to improve your skills.

RHEA DADOO

RHEADADOODLES.TUMBLR.COM

HI THERE! I'M FROM SAN JOSE, CALIFORNIA. I'M CURRENTLY A CHARACTER ANIMATION STUDENT AT THE CALIFORNIA INSTITUTE OF THE ARTS, HOPING TO PURSUE STORYBOARDING OR VISUAL DEVELOPMENT.

WHY DO YOU KEEP A SKETCH JOURNAL?

FIRST OF ALL, IT KEEPS ME OCCUPIED! I LIKE TO ALWAYS BE DOING SOMETHING, SO IF I'M JUST SITTING AROUND, IT'S TIME TO PULL OUT THE SKETCHBOOK. DOODLING OR JOTTING DOWN A DRAWING THAT DEMONSTRATES MY FEELINGS HELPS CALM DOWN ME WHEN I AM STRESSED. MY SKETCH JOURNAL ALSO SERVES AS A SPACE TO EXPLORE STORY OR CHARACTER IDEAS THAT I CAN REVISIT IN THE FUTURE.

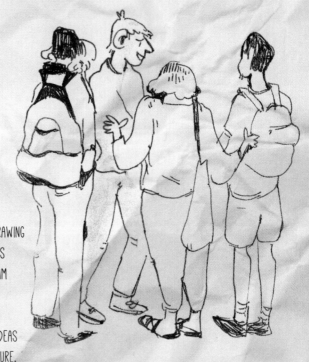

MY FAVORITE THING TO DRAW

DRAWING WITH STICKY NOTES

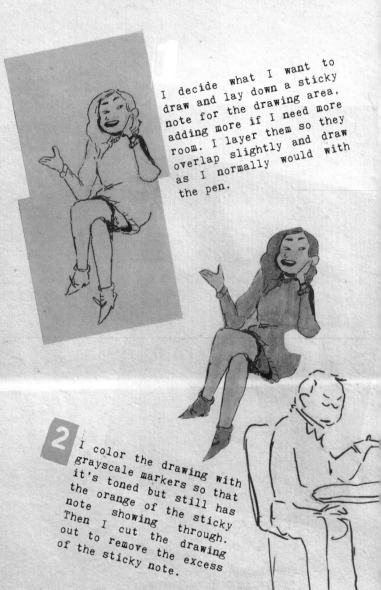

I decide what I want to draw and lay down a sticky note for the drawing area, adding more if I need more room. I layer them so they overlap slightly and draw as I normally would with the pen.

2 I color the drawing with grayscale markers so that it's toned but still has the orange of the sticky note showing through. Then I cut the drawing out to remove the excess of the sticky note.

* Sticky notes
* Pen
* Markers
* Scissors
* Glue

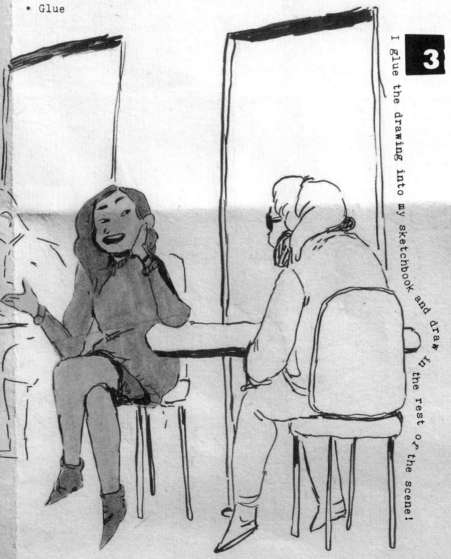

3 I glue the drawing into my sketchbook and draw in the rest of the scene!

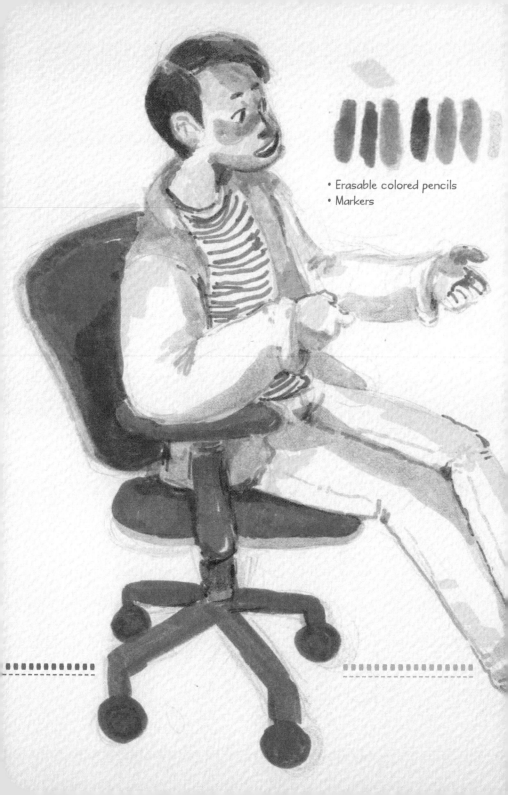

- Erasable colored pencils
- Markers

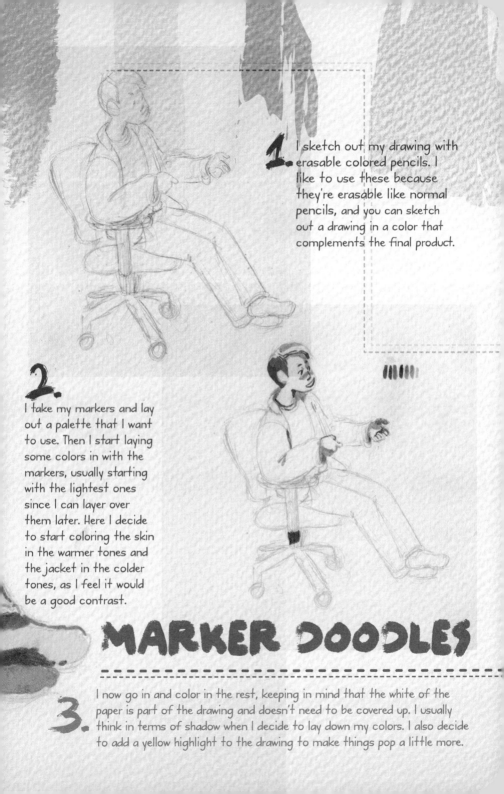

1. I sketch out my drawing with erasable colored pencils. I like to use these because they're erasable like normal pencils, and you can sketch out a drawing in a color that complements the final product.

2. I take my markers and lay out a palette that I want to use. Then I start laying some colors in with the markers, usually starting with the lightest ones since I can layer over them later. Here I decide to start coloring the skin in the warmer tones and the jacket in the colder tones, as I feel it would be a good contrast.

MARKER DOODLES

3. I now go in and color in the rest, keeping in mind that the white of the paper is part of the drawing and doesn't need to be covered up. I usually think in terms of shadow when I decide to lay down my colors. I also decide to add a yellow highlight to the drawing to make things pop a little more.

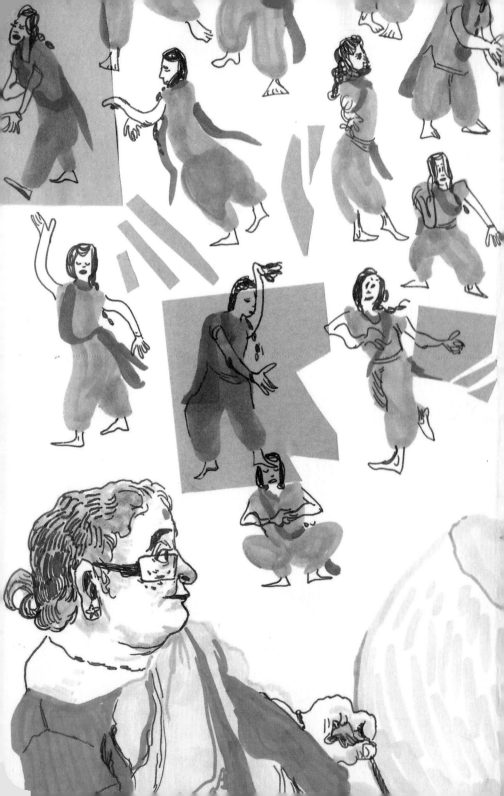

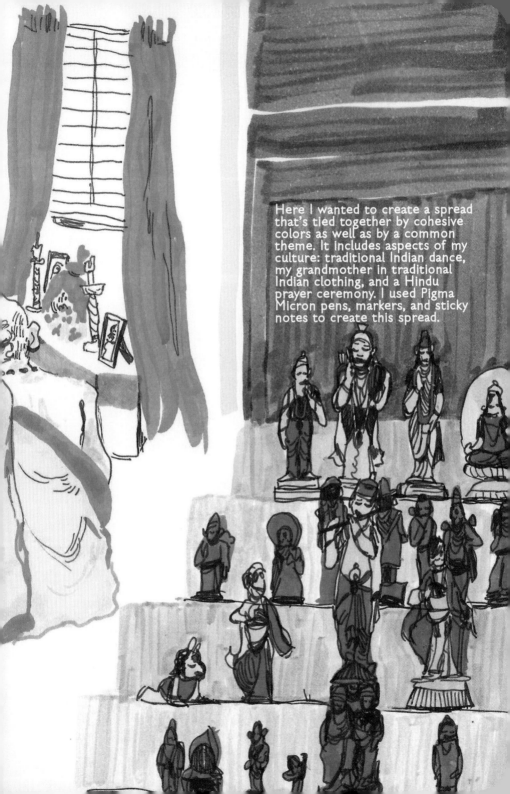

Here I wanted to create a spread that's tied together by cohesive colors as well as by a common theme. It includes aspects of my culture: traditional Indian dance, my grandmother in traditional Indian clothing, and a Hindu prayer ceremony. I used Pigma Micron pens, markers, and sticky notes to create this spread.

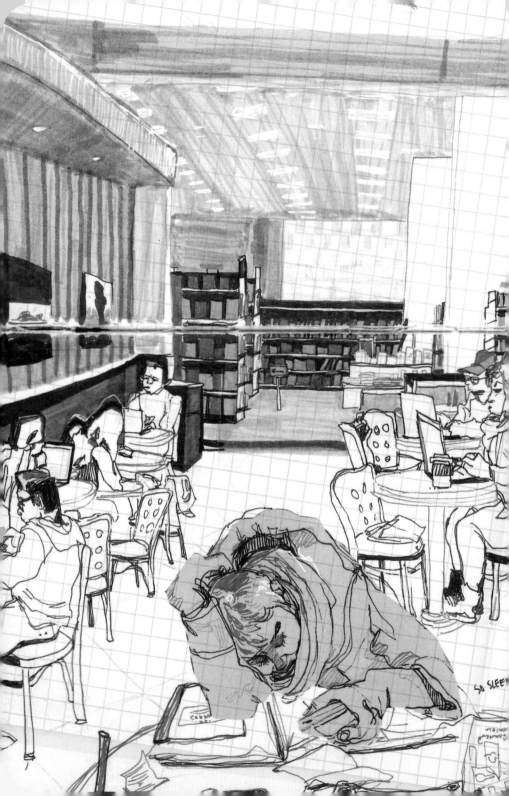

EXPERIMENT!

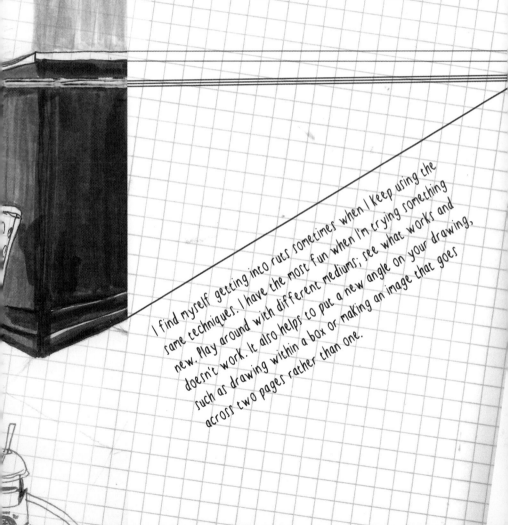

I find myself getting into ruts sometimes when I keep using the same techniques. I have the most fun when I'm trying something new. Play around with different mediums; see what works and doesn't work. It also helps to put a new angle on your drawing, such as drawing within a box or making an image that goes across two pages rather than one.

DERRICK DENT

derrickdent.com

I'm originally from Memphis, Tennessee. I'm an illustrator and comic artist, pursuing editorial work and working on a graphic novel in New York, where I currently live.

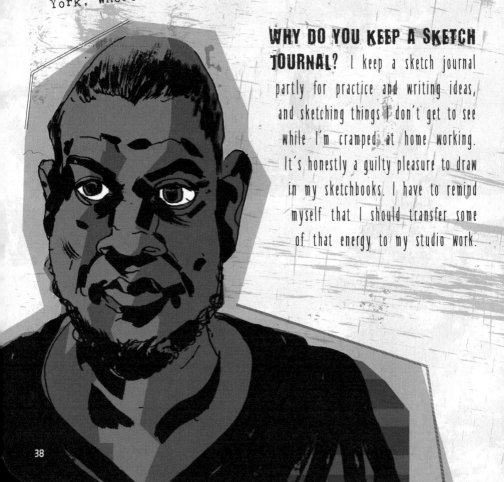

WHY DO YOU KEEP A SKETCH JOURNAL? I keep a sketch journal partly for practice and writing ideas, and sketching things I don't get to see while I'm cramped at home working. It's honestly a guilty pleasure to draw in my sketchbooks. I have to remind myself that I should transfer some of that energy to my studio work.

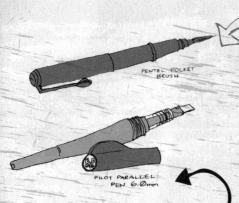

PENTEL POCKET
BRUSH

PILOT PARALLEL
PEN 6.0mm

Pentel Pocket Brush Pen: Portable solution for ink and brush drawing. I use it for dry brush effects and filling in areas with black. Some use it for lush line work, but my heavy-handed drawing limits my use for it to a fill tool. Very versatile, and refillable - you can purchase ink cartridges separately.

Pilot Parallel Pen: Mostly for fine line drawing, sometimes for fancy calligraphic mark-marking. It's currently my favorite as it provides the kind of nuanced line I enjoy with nibs, and it has a bit of a 'random' element to it because of the ink feed - not for everyone, though! It's also refillable, and you can buy the ink cartridges separately.

Stabilo Aquarellable 8052 Pencil: I generally use this as a water-soluble "wash" pencil. I use it as a way to quickly control the value of areas in my ink drawings. It's awesome for layering and creating interesting textures.

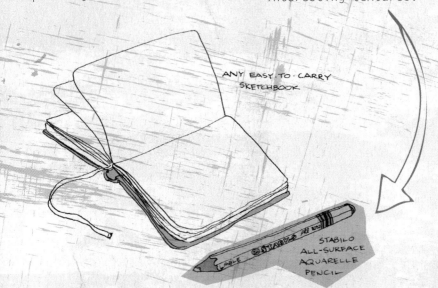

ANY EASY-TO-CARRY
SKETCHBOOK

STABILO
ALL-SURFACE
AQUARELLE
PENCIL

1. First block in the objects in your sketch, focusing on the forms and external contours of each item, and how they relate to each other spatially. Focus on the basic outline of everything, almost like you're drawing out a silhouette using line. Take the time to map out your next steps with a few leading lines and marks.

2. Start assessing what you're looking at and where lines and diagonals converge. This helps you figure out where to start drawing the interior forms within the larger shapes. Think dimensionally. Think about the sides and planes of the objects you're drawing. The lines you draw should be responding to form in some way.

3. You'll be using ink shadows to convey form in this step, and that is most effective when there is a consistency in the direction of those shadows. There are some exceptions, but since ink often has a binary value range, be very mindful of forms. Start making judgments about which forms and objects can be consolidated in shadow.

I USE A PARALLEL PEN (THOUGH YOU CAN USE ANY FINE LINE PEN) AND POCKET BRUSH (ALTERNATIVELY, BRUSH AND INK, OR COMPARABLE BRUSH PEN).

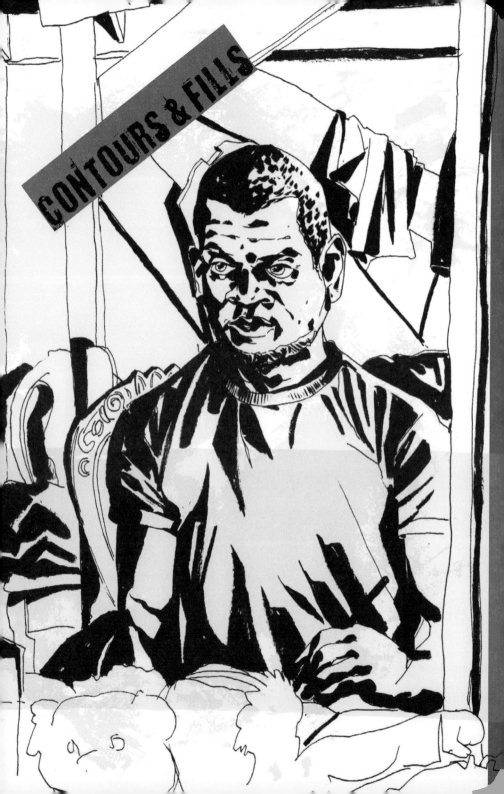

CONTOURS & FILLS

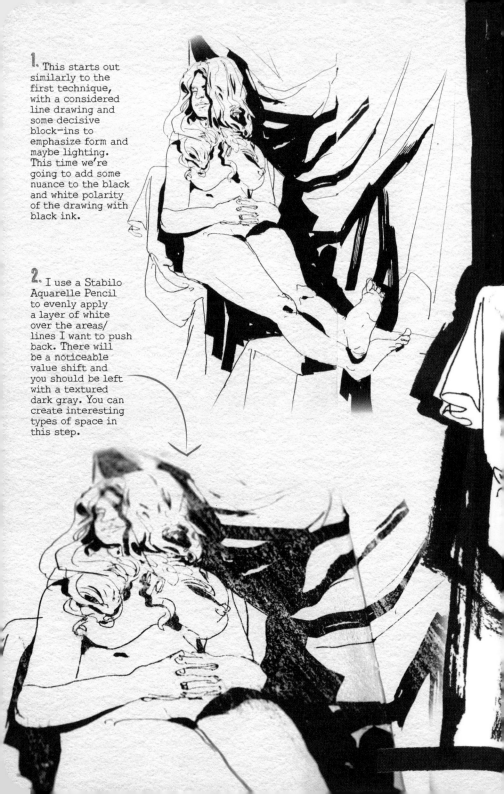

1. This starts out similarly to the first technique, with a considered line drawing and some decisive block—ins to emphasize form and maybe lighting. This time we're going to add some nuance to the black and white polarity of the drawing with black ink.

2. I use a Stabilo Aquarelle Pencil to evenly apply a layer of white over the areas/ lines I want to push back. There will be a noticeable value shift and you should be left with a textured dark gray. You can create interesting types of space in this step.

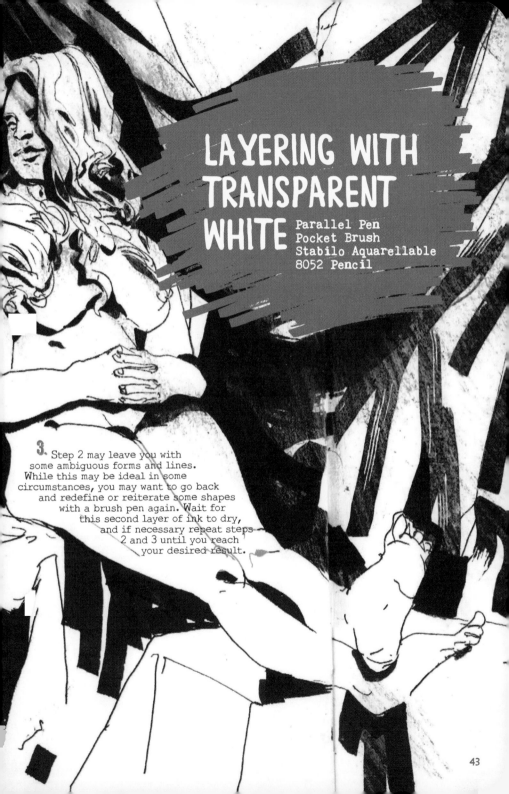

LAYERING WITH TRANSPARENT WHITE

Parallel Pen
Pocket Brush
Stabilo Aquarellable
8052 Pencil

3. Step 2 may leave you with some ambiguous forms and lines. While this may be ideal in some circumstances, you may want to go back and redefine or reiterate some shapes with a brush pen again. Wait for this second layer of ink to dry, and if necessary repeat steps 2 and 3 until you reach your desired result.

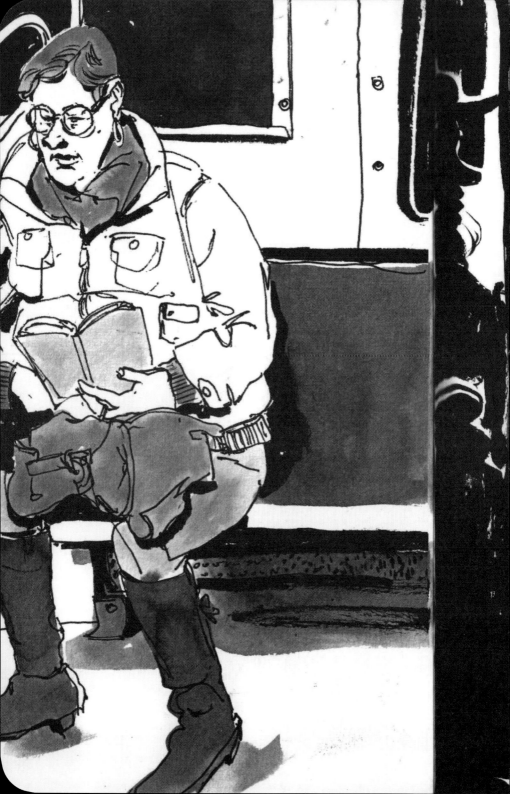

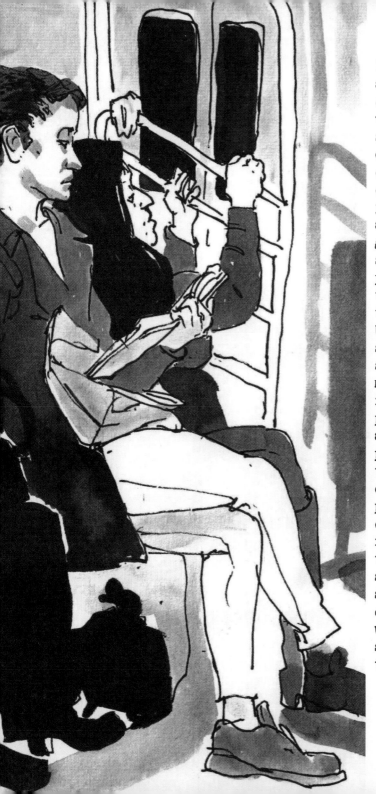

I do a fair amount of commuting via the subway, and depending on the time of day, you'll get a very good cross-section of people in the city. I typically bring a small sketchbook, my favorite fine line pens, and a brush pen, since they're easier to pull out on the fly, and try to get some decent sketches of commuters when I have some time to kill.

THE BEST ADVICE I GOT ABOUT **SKETCHBOOKS** WAS FROM BARRON STOREY WHEN HE VISITED MY UNDERGRAD. ILLUSTRATION CLASS. INSTEAD OF THINKING OF A SKETCHBOOK AS A CHORE TO KEEP UP WITH, THINK OF IT AS YOUR **DIARY**, WHICH IS SOMETHING THAT RELATES MORE TO YOUR LIFE. YOU'LL BE **SURPRISED** BY HOW SEMANTICS CAN MAKE A DIFFERENCE.

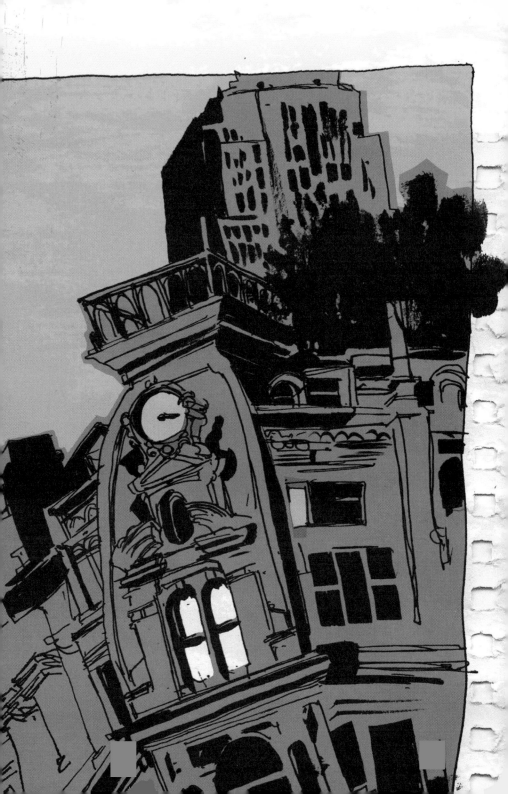

I'm an artist, cartoonist, and stay-at-home dad from Montreal, Canada.

Michel Hellman

michelhellman.com

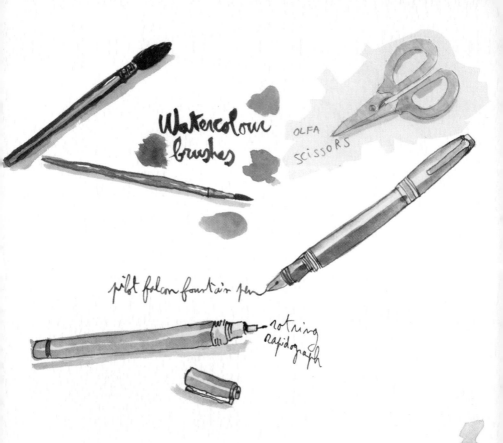

Watercolour brushes

OLFA SCISSORS

pilot falcon fountain pen

rotring rapidograph

Why do you keep a sketch journal?

At first, I carried around a sketchbook as a way to improve my drawing skills. I would try to draw everything around me from observation: cars, bicycles, animals, people in cafés, and so on. I soon realized that it had become a very effective way to record my everyday life. I now treat it like a visual diary. I still do a lot of sketching, but I also include collages, notes, my children's drawings, and more...

49

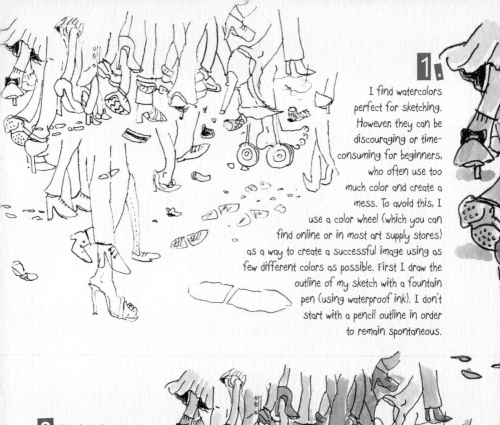

1. I find watercolors perfect for sketching. However, they can be discouraging or time-consuming for beginners, who often use too much color and create a mess. To avoid this, I use a color wheel (which you can find online or in most art supply stores) as a way to create a successful image using as few different colors as possible. First I draw the outline of my sketch with a fountain pen (using waterproof ink). I don't start with a pencil outline in order to remain spontaneous.

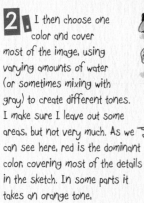

2. I then choose one color and cover most of the image, using varying amounts of water (or sometimes mixing with gray) to create different tones. I make sure I leave out some areas, but not very much. As we can see here, red is the dominant color, covering most of the details in the sketch. In some parts it takes an orange tone.

3. I then use a color wheel to see what the complementary (opposite) hues are which will fit with the dominant color I've used. In this example (see top right), we can see that by adding just a few spots of blue, green, and yellow, the image becomes much livelier. We get the impression that there are a lot of colors, when in reality I've just used a few. This trick saves a lot of time and frustration!

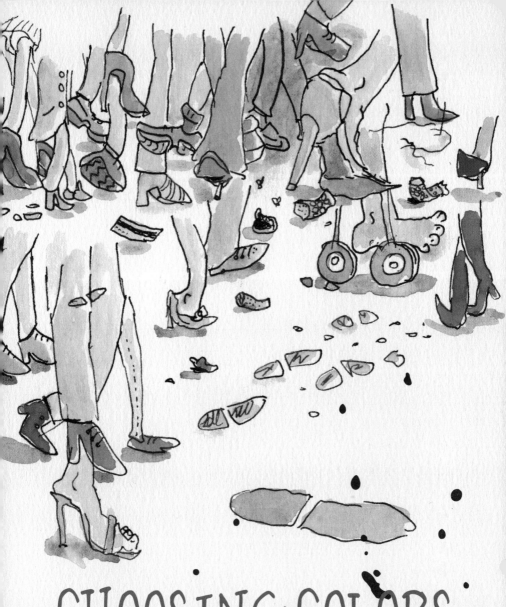

CHOOSING COLORS ...WISELY

*Fountain Pen,
Watercolor, Color Wheel*

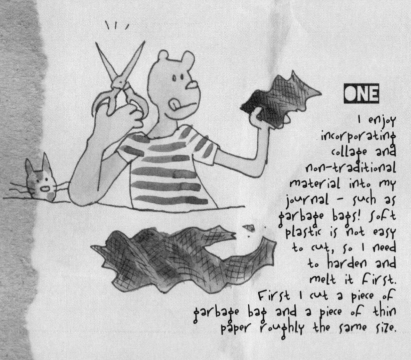

ONE

I enjoy incorporating collage and non-traditional material into my journal — such as garbage bags! Soft plastic is not easy to cut, so I need to harden and melt it first. First I cut a piece of garbage bag and a piece of thin paper roughly the same size.

TWO

I then put the piece of paper and piece of plastic between two cooking sheets and pass a dry clothes iron on them.

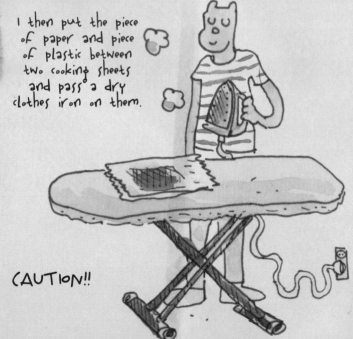

CAUTION!!

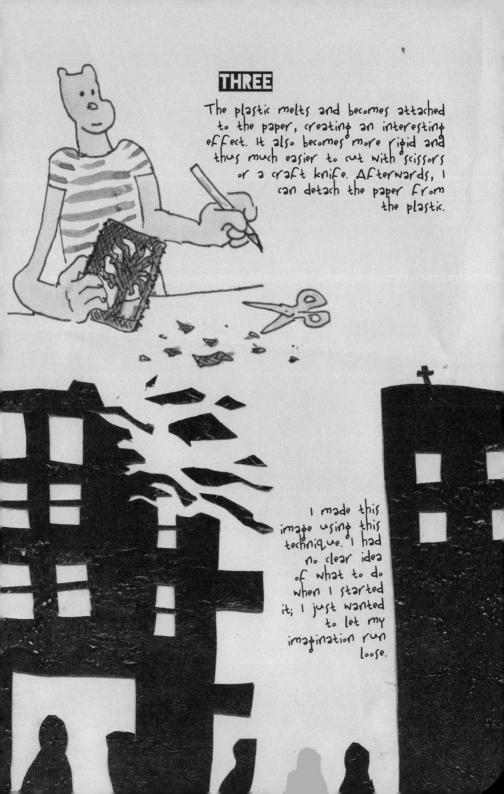

THREE

The plastic melts and becomes attached to the paper, creating an interesting effect. It also becomes more rigid and thus much easier to cut with scissors or a craft knife. Afterwards, I can detach the paper from the plastic.

I made this image using this technique. I had no clear idea of what to do when I started it; I just wanted to let my imagination run loose.

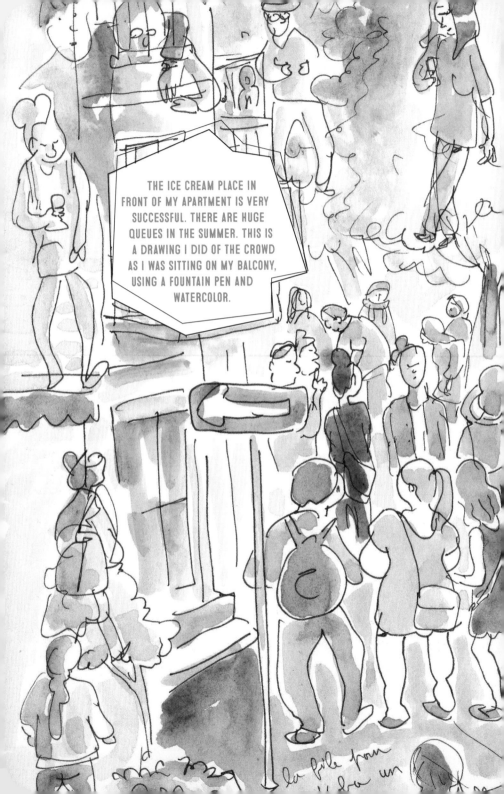

THE ICE CREAM PLACE IN FRONT OF MY APARTMENT IS VERY SUCCESSFUL. THERE ARE HUGE QUEUES IN THE SUMMER. THIS IS A DRAWING I DID OF THE CROWD AS I WAS SITTING ON MY BALCONY, USING A FOUNTAIN PEN AND WATERCOLOR.

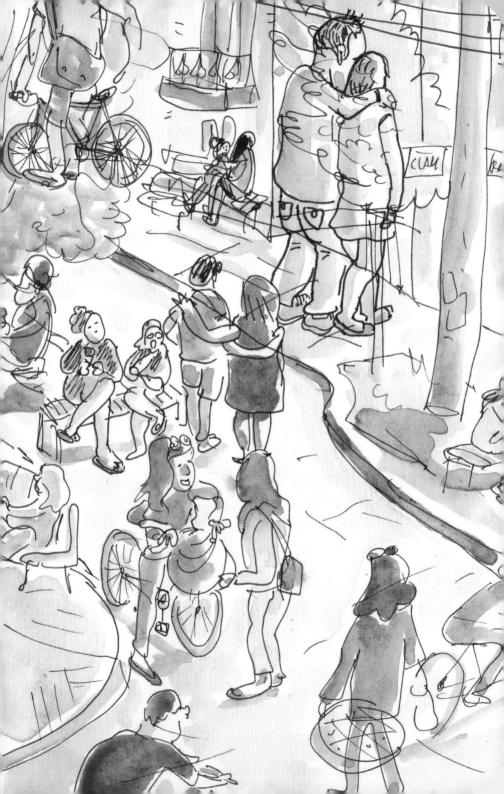

This is a drawing of the Inuit community of Kangirsuk in Northern Québec. The setting is beautiful in the Ungava Bay but the *mosquitoes* were insane! I tried to capture the essence of what I saw before rushing back indoors....

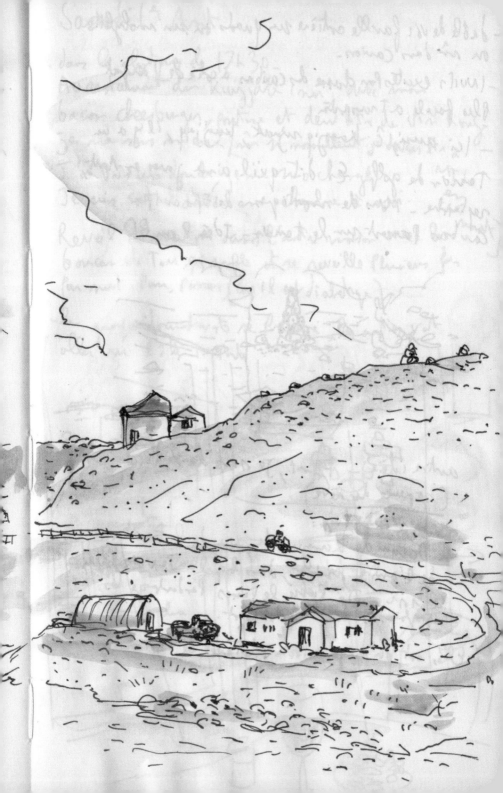

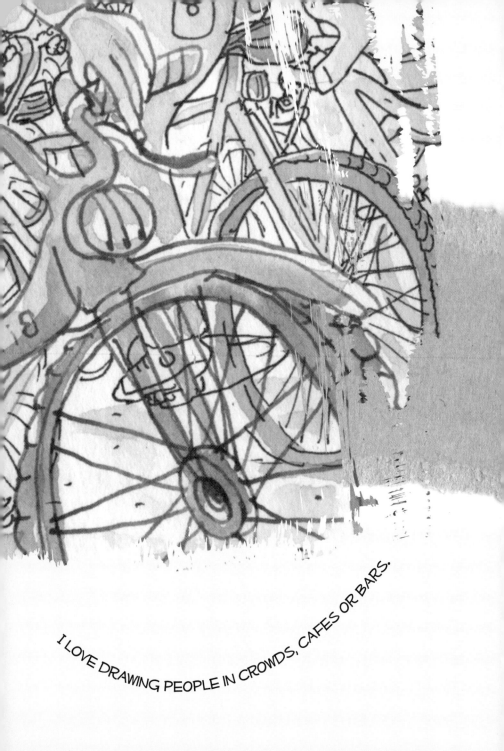

I LOVE DRAWING PEOPLE IN CROWDS, CAFES OR BARS.

My ADVICE would be to carry your sketch journal with you wherever you go and to sketch all the time! There is rarely a "perfect" moment so you have to make an effort to pull out your journal and your material and start drawing what is around you, even if it makes you a **little uncomfortable or shy at first** It will quickly start to feel more natural as you go and eventually become extremely ADDICTIVE!

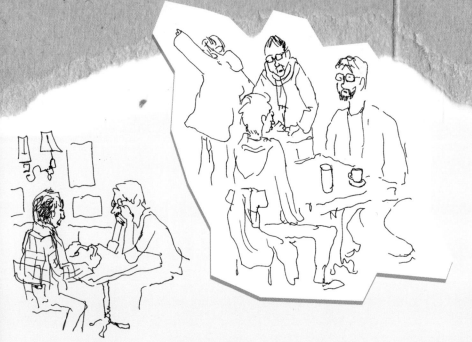

DEBORAH JUNG-JIN LEE

→ DEBORAHJLEE.COM ←

I'VE LIVED EVERYWHERE, BUT MOSTLY IN SUMMIT, NEW JERSEY. I'M CURRENTLY AN UNDERGRAD. AT CARNEGIE MELLON UNIVERSITY'S SCHOOL OF DESIGN, WHERE I ILLUSTRATE ON THE SIDE AND KEEP MYSELF CAFFEINATED.

WHY DO YOU KEEP A SKETCH JOURNAL?

APART FROM HAVING A SEPARATE JOURNAL FOR IDEAS AND DESIGN ITERATIONS, THE JOURNAL PAGES SHOW THINGS THAT ARE MORE PERSONAL TO ME. I'VE ALWAYS HAD AN AFFINITY FOR FILLING BOOKS FROM COVER TO COVER. KEEPING A SKETCH JOURNAL IS A REFERENCE FOR THE FUTURE. NOT ONLY DOES IT SHOW HOW PRODUCTIVE I'VE BEEN, BUT ALSO WHAT I'VE BEEN THINKING AND WHAT WAS HAPPENING AT THAT MOMENT. IT IS AN INDIRECT DIARY.

MY FAVORITE THINGS TO DRAW ARE HANDS, DEER ANTLERS, PLANTS, AND HAIR.

MY FAVORITE TOOLS AND MATERIALS INCLUDE MICRON PENS, COPIC MARKERS, PAINT MARKERS, AND MAGAZINE SCRAPS.

MICRON

MICRONS AND OTHER ASSORTED PENS. (01, 03, 2)

COPICS AND ANY MARKER I CAN FIND.

COPIC SKETCH

MAGAZINE SCRAPS.

PAINT MARKERS

SHADING & MAKING TEXTURES WITH LINES

Tools used: Fine liner

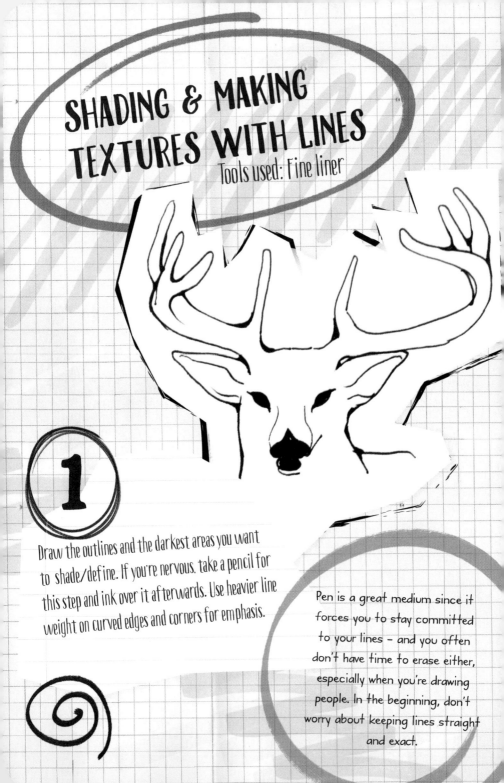

1

Draw the outlines and the darkest areas you want to shade/define. If you're nervous, take a pencil for this step and ink over it afterwards. Use heavier line weight on curved edges and corners for emphasis.

Pen is a great medium since it forces you to stay committed to your lines – and you often don't have time to erase either, especially when you're drawing people. In the beginning, don't worry about keeping lines straight and exact.

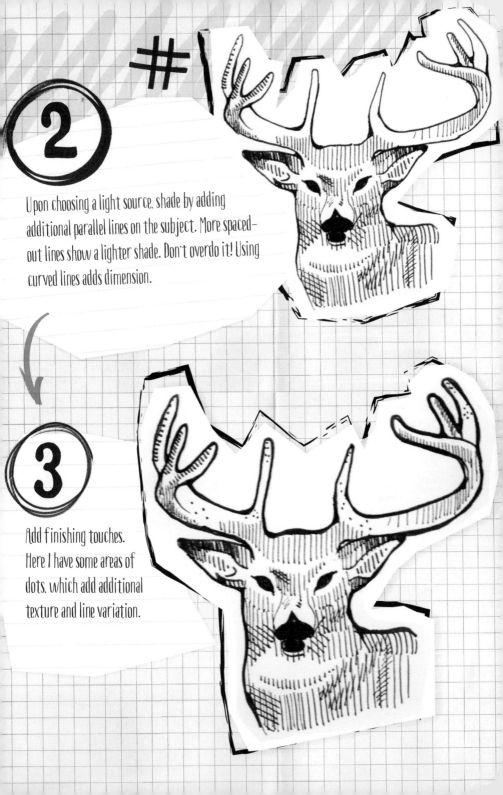

2

Upon choosing a light source, shade by adding additional parallel lines on the subject. More spaced-out lines show a lighter shade. Don't overdo it! Using curved lines adds dimension.

3

Add finishing touches. Here I have some areas of dots, which add additional texture and line variation.

COLORING
WITH LAYERS

PENS, MARKERS, PAINT MARKERS

1 DRAW YOUR BACKGROUND BUT TRY NOT TO MAKE IT TOO DETAILED – A CONSISTENT, NON-DISTRACTING PATTERN WILL SUFFICE.

ALTHOUGH HIGH CONTRAST IS HELPFUL, TOO MUCH OF IT IN ONE PIECE CAN BECOME OVERWHELMING. IT'S HEALTHY TO AVOID USING BLACK AND WHITE AT THE SAME TIME ONCE IN A WHILE, AND IT GIVES YOU A CHANCE TO EXPERIMENT WITH VARIOUS COLORS.

GOODNIGHT

USE A COLORED PEN TO DRAW OVER YOUR PATTERN (IF YOU'RE NEW TO INK, SEE THE PREVIOUS TUTORIAL). HERE I ADOPT A SLIGHTLY THICKER LINE WEIGHT AROUND THE EDGES, SO THEY JUMP OUT AT THE VIEWER MORE EASILY. IF YOU WANT, COLOR IN A COUPLE OF AREAS FOR CONTRAST.

COLOR THE AREA AROUND THE OBJECT/TEXT WITH A DARKER COLOR. HERE I'VE USED A PAINT MARKER. I ALSO COLORED IN THE TEXT — PURPLE STANDS OUT MORE IN THIS CASE.

GOODNIGHT

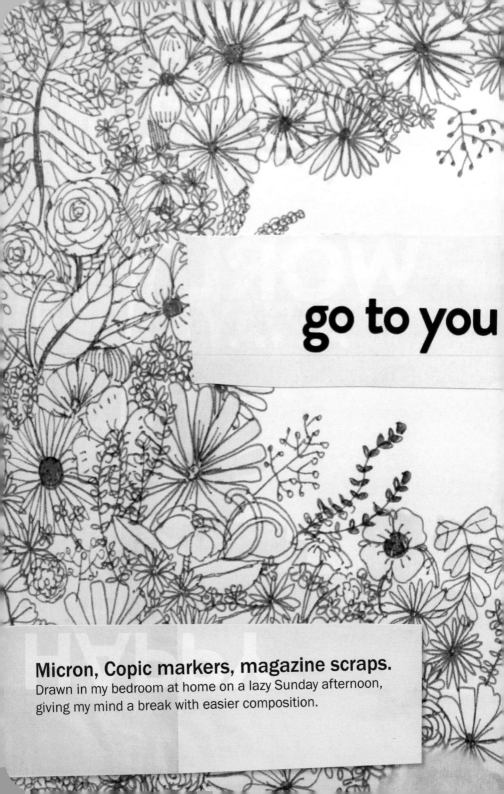

go to you

Micron, Copic markers, magazine scraps.
Drawn in my bedroom at home on a lazy Sunday afternoon,
giving my mind a break with easier composition.

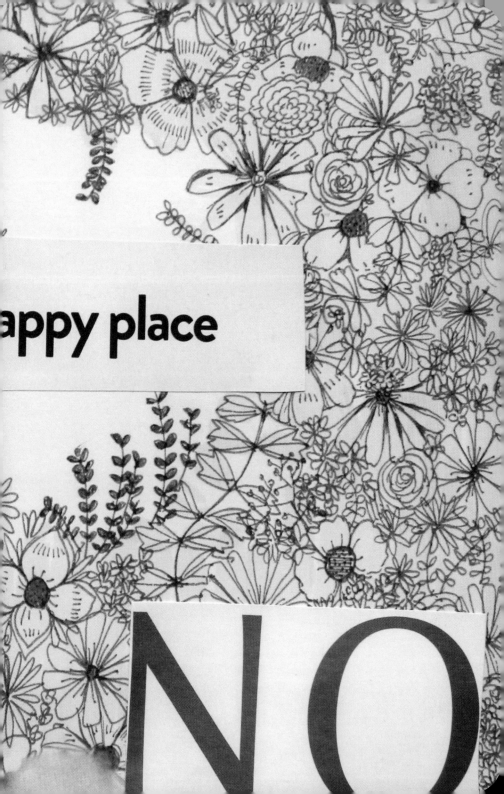

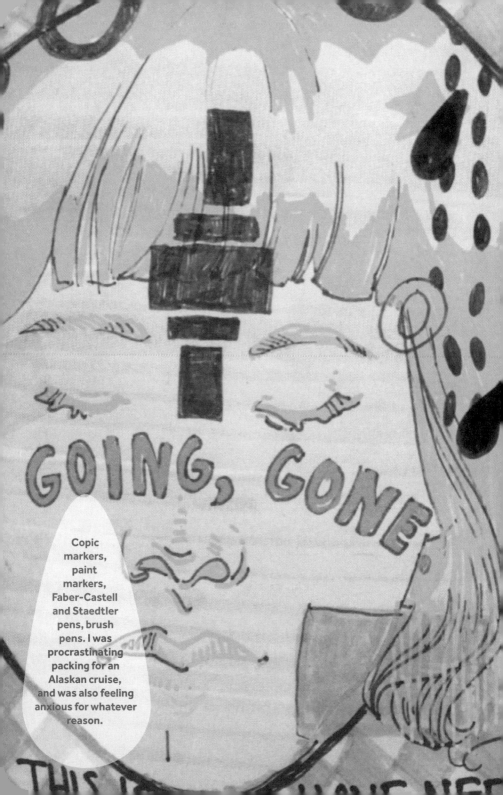

GOING, GONE.

Copic markers, paint markers, Faber-Castell and Staedtler pens, brush pens. I was procrastinating packing for an Alaskan cruise, and was also feeling anxious for whatever reason.

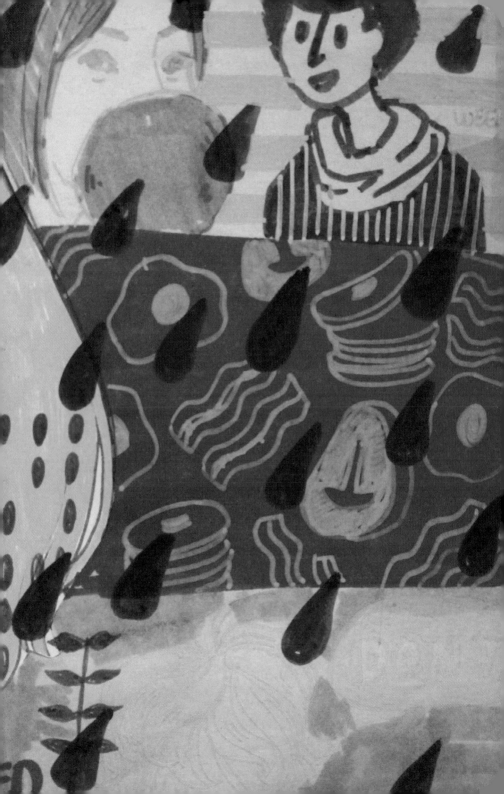

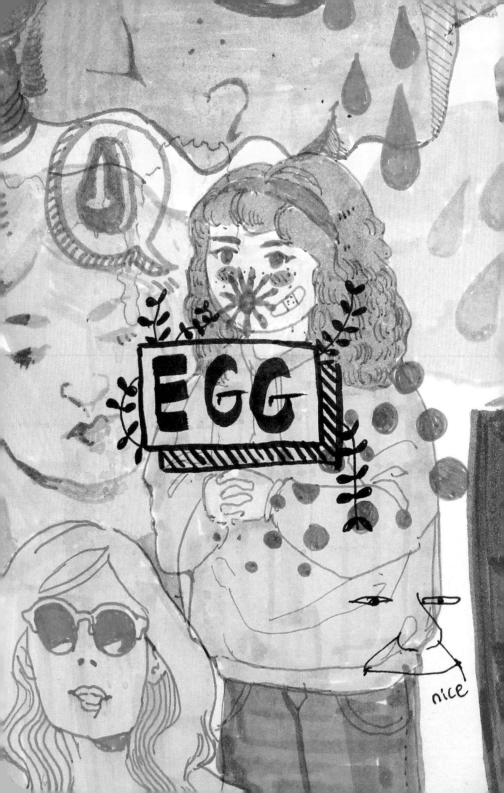

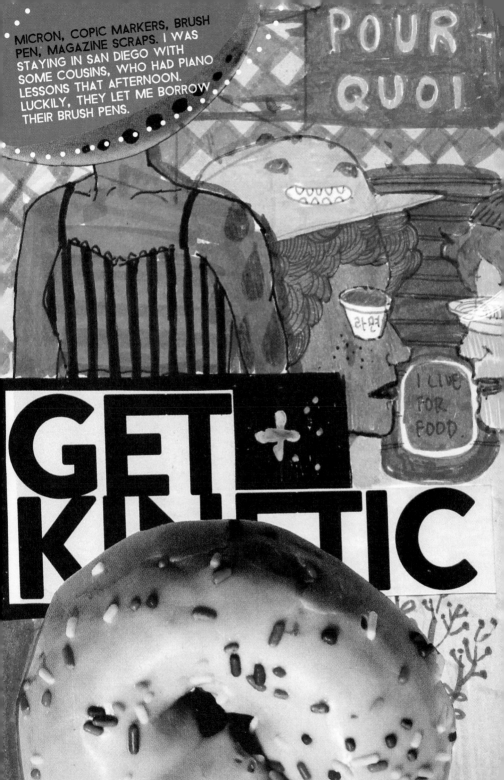

MICRON, COPIC MARKERS, BRUSH PEN, MAGAZINE SCRAPS. I WAS STAYING IN SAN DIEGO WITH SOME COUSINS, WHO HAD PIANO LESSONS THAT AFTERNOON. LUCKILY, THEY LET ME BORROW THEIR BRUSH PENS.

POUR QUOI

I LIVE FOR FOOD.

GET + KINTIC

What advice would you give to someone who's just getting into sketching?

Draw everything in your surroundings, anything at all. You can only get better with practice. If you're really new to drawing, start simple: use one color ink. Then, start experimenting with shading, using other colors. Maybe move on to marker. Try not to worry about art block - it may hit you at some point, but you still have your surroundings to draw until you overcome it.

Briony May Smith

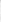

Hi, I'm a freelance illustrator currently living in Berkshire, UK, who specializes in children's books for all ages and graphic novels. I graduated with a first-class BA (Hons) in Illustration from Falmouth University in 2014. My stories and pictures take inspiration from folklore and fairytales, and a love of the outdoors.

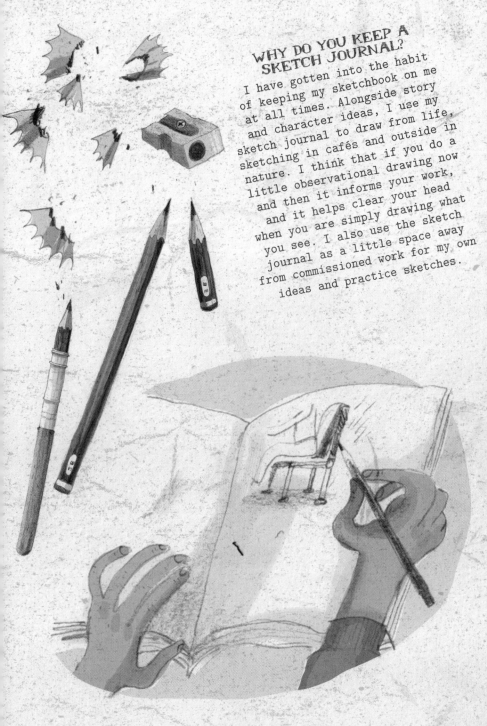

WHY DO YOU KEEP A SKETCH JOURNAL?

I have gotten into the habit of keeping my sketchbook on me at all times. Alongside story and character ideas, I use my sketch journal to draw from life, sketching in cafés and outside in nature. I think that if you do a little observational drawing now and then it informs your work, and it helps clear your head when you are simply drawing what you see. I also use the sketch journal as a little space away from commissioned work for my own ideas and practice sketches.

OUT & ABOUT

SOME TIPS ON SOME KEY PLACES TO DRAW AND WHY

COFFEE SHOPS

These are great places to work on your figure drawing, sketching people inside or outside. People aren't moving too quickly, giving you plenty of time to draw them! Choose a window seat so that you aren't limited to inside the café.

THE GREAT OUTDOORS

Drawing your surroundings is as important as drawing figures and animals. This can be in a park, on a hike, at the beach. It helps to practice backgrounds so your figures aren't floating in space. It helps you to observe light and shadow. It's also difficult to draw simple things like trees from your imagination if you haven't practiced from life. After practicing, you can later amalgamate the trees you've drawn from observation in your work and they'll seem more real.

CITIES AND TOWNS

If you're in London for the day, or on a city break, cities and towns are a great place to draw! Find a comfy spot with a great view, sit on some city steps or have a drink in a window seat. It's too busy for people to notice you and people move too fast for you to worry about figure drawing details.

It's also great to draw buildings and landmarks, and for me these are a great change from the usual sketchbook content. They are also a break from quickfire crowd sketches, and they challenge your observation of light when the sun is shining and the shadows are strong.

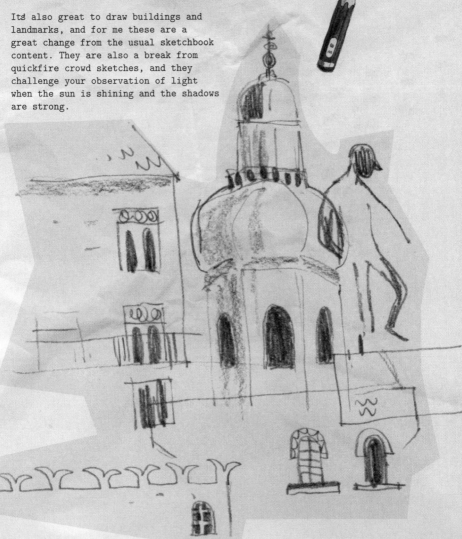

HELPFUL TIPS FOR OBSERVATIONAL WORK

1. Don't get bogged down by detail

You should try to draw as quickly as possible and not worry about too much detail! It's great to draw from life because it strips drawing down to the essentials. Focusing on the detail of someone's hat won't help you practice figures; also you might look up and that person has walked away.

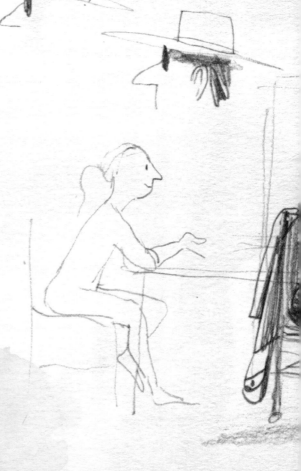

2. Subtlety is key!

Remember to be sly! Don't nod your head up and down because people will notice you are drawing them and this can be uncomfortable for you and for them! The key is to flick your eyes up and down to make it less obvious you are immortalizing your subject in your sketch journal! Pretend you are writing a shopping list and you won't get any unwelcome attention!

3. Really observe your subject

Look at what you are drawing more than at your journal. You need to observe everything - how a person is slouched in his chair, how two friends lean in to chat, how a lady is hunched over a laptop. These are details you won't notice if you're busy shading a table leg. Draw quickly and efficiently and make sure you keep looking up!

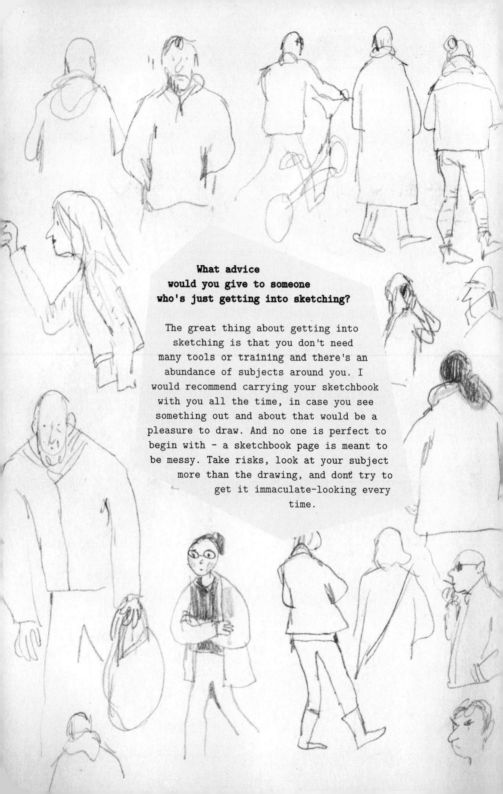

**What advice
would you give to someone
who's just getting into sketching?**

The great thing about getting into
sketching is that you don't need
many tools or training and there's an
abundance of subjects around you. I
would recommend carrying your sketchbook
with you all the time, in case you see
something out and about that would be a
pleasure to draw. And no one is perfect to
begin with - a sketchbook page is meant to
be messy. Take risks, look at your subject
more than the drawing, and don't try to
get it immaculate-looking every
time.

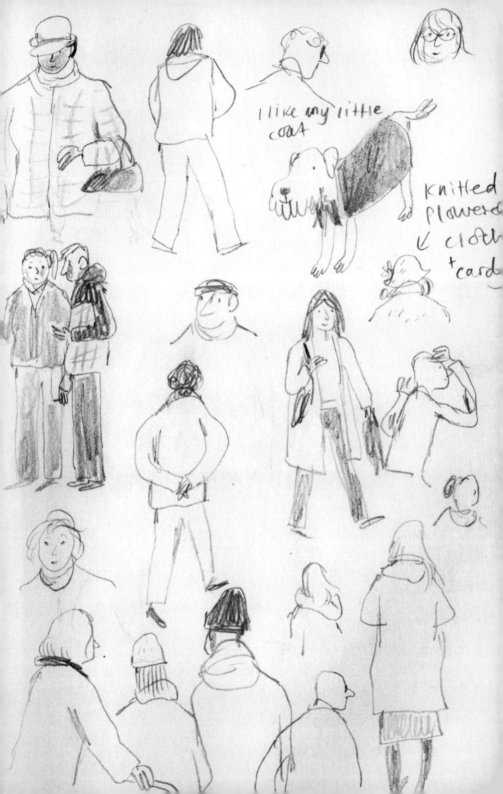

I like any little coat

Knitted
Flowered
← cloth
+ card

DAWN✳TAN

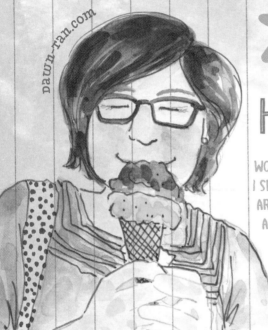

dawn-tan.com

HELLO! I'M AN ARTIST
AND ILLUSTRATOR LIVING AND
WORKING IN MELBOURNE, AUSTRALIA.
I SPEND MY DAYS BETWEEN TEACHING
ART TO BOTH ADULTS AND CHILDREN,
AS WELL AS WORKING ON A RANGE
OF FREELANCE AND PERSONAL
PROJECTS!

WHY DO YOU KEEP A SKETCH JOURNAL?

I find keeping a journal a really fun yet personal
way of documenting my art journey. I like the idea
of being able to record a moment by painting and
drawing, then looking back at that moment again in a
few years' time. I find that very special and magical!

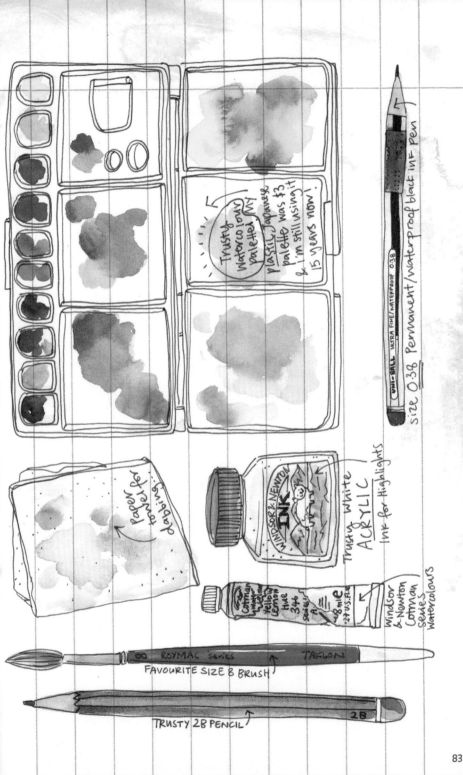

Trusty
Watercolour palette!
Plastic Japanese palette was $3 & I'm still using it 15 years now!

Size 0.38 Permanent/waterproof black ink pen

UNI-BALL ULTRA FINE/WATERPROOF 0.38

Paper for testing dabbing

WINDSOR & NEWTON INK

Trusty White ACRYLIC
Ink for Highlights

Cotman Artist Yellow Lemon Hue 3++ series A 8 mle 27 US.FL.oz

Windsor & Newton Cotman Series Watercolours

ROYMAC series TAKLON
FAVOURITE SIZE 8 BRUSH

TRUSTY 2B PENCIL 2B

83

LAYERING OF COLORS

* Watercolors
* Brush

1. Watercoloring is essentially all about layering! I always make it a point to start light, then work my way up gradually with darker tones. Say if we paint a banana, for example, I would start off with a first layer of a lightly painted yellow patch that is drawn in the shape of the banana.

notice how I am not even thinking about my tones/shading yet. my focus is just to use a light yellow first for the FIRST LAYER!!

1st layer 2nd layer 3rd layer 4th layer 5th layer

Basic layering of colours (FROM lightest shade to the darkest)

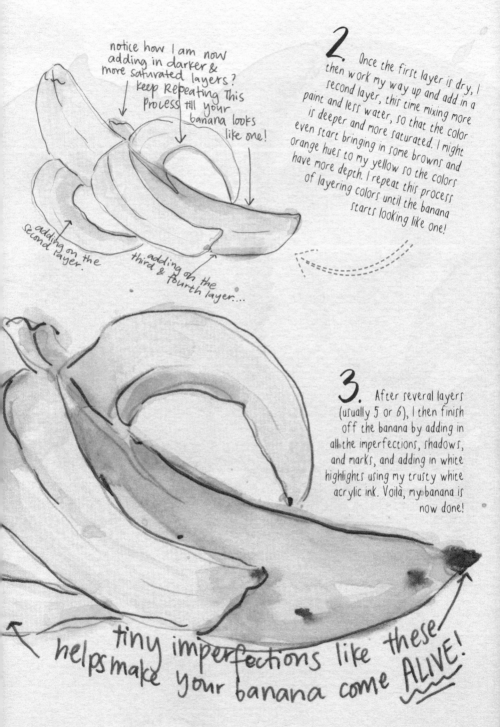

notice how I am now adding in darker & more saturated layers? keep Repeating This Process till your banana looks like one!

adding on the second layer.

adding on the third & fourth layer...

2. Once the first layer is dry, I then work my way up and add in a second layer, this time mixing more paint and less water, so that the color is deeper and more saturated. I might even start bringing in some browns and orange hues to my yellow so the colors have more depth. I repeat this process of layering colors until the banana starts looking like one!

3. After several layers (usually 5 or 6), I then finish off the banana by adding in all the imperfections, shadows, and marks, and adding in white highlights using my trusty white acrylic ink. Voilà, my banana is now done!

tiny imperfections like these helps make your banana come ALIVE!

Adding dry brush textures

1 When painting foods such as **ONIONS**, artichokes, and garlic, one of my favorite things to do is to add on a dry brush texture right at the end. This helps to "lift" the object and makes it way more exciting to look at. Dry brush strokes are super easy to achieve. Artists tend to like using a fan-shaped brush, but I like using a size 8 regular brush. I pinch the hairs of my brush using my thumb and middle finger. Rubbing these two fingers together, the brush hairs will start separating to form a lovely **FAN SHAPE..**

* Watercolors
* Brush
* Spare paper

Fan-shaped brush ↑

dry brush stroke

Regular size 8 brush ↑
which is what I use!

regular brush stroke

dry brush strokes on a painted ground.

gently rub =

place thumb here.

place middle finger here.

X Too wet! ↑

getting ↑
there...

practice
makes for
perfection!

*Notice how it's
actually not so
easy to achieve a
nice fan/textured
stroke on the first go?

perfect!!

2. Using some of the wet paint which I've pre-mixed before **RUBBING MY FINGERS,** I gently pick up some of the paint and start doing a few test STROKES on a separate sheet of paper. This helps to get any excess water off your brush. [Excess water makes your strokes all blurry!]

3. Once I am fully satisfied with the amount of water I have on my brush [it shouldn't be **TOO WET,** nor too dry], I can then proceed to paint in the dry strokes on my garlic! Voilà,

AND IT'S DONE!

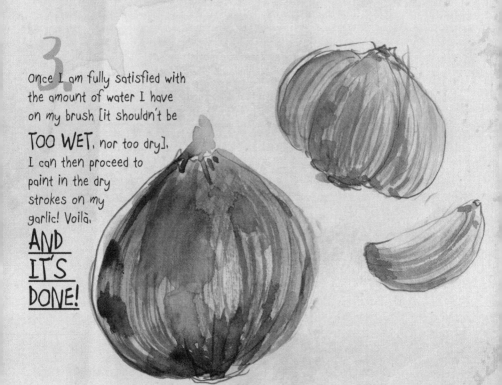

Pizza Ideas

mushrooms

Salami

cracked pepper

grated Parmesan

Hawaiian

pineapple?

Brocoli & Sausage
* like the one at D.O.C

The Best of all
Buffalo Mozarella!

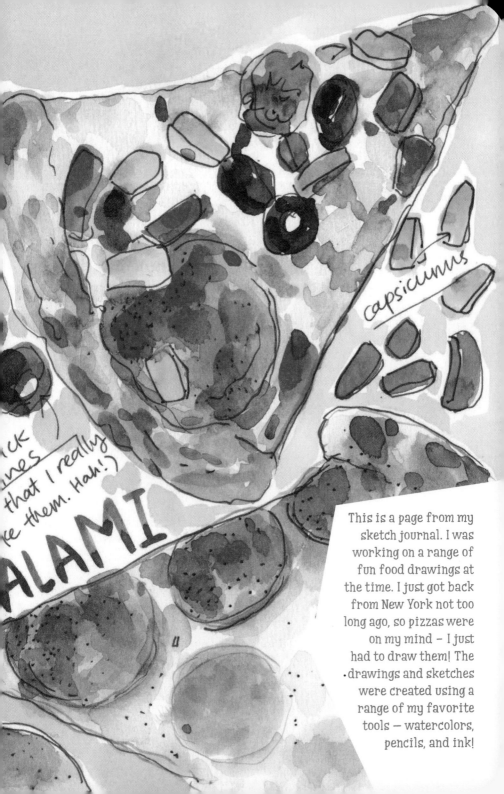

capsicuuus

ck
nes
that I really
ke them. Hah!)

ALAMI

This is a page from my sketch journal. I was working on a range of fun food drawings at the time. I just got back from New York not too long ago, so pizzas were on my mind – I just had to draw them! The drawings and sketches were created using a range of my favorite tools — watercolors, pencils, and ink!

Food, oh glorious food

THE COLORS, SMELLS, TEXTURES, THEY ALL INSPIRE ME

I ALSO REALLY LOVE PAINTING PLANTS

WHAT ADVICE WOULD YOU GIVE TO SOMEONE WHO'S JUST GETTING INTO SKETCHING?

Just go for it and don't stop. You never know where it might lead you. I sketched because I was bored in class back when I was a teen and I have not stopped since. It's just such a great outlet to process your thoughts. Don't worry about keeping it all too pretty. Just have fun with it and draw whatever you want. Letting your ideas flow organically — that's the best!

MAJA WROŃSKA

I'M AN ARCHITECT FROM POLAND. I GRADUATED FROM THE FACULTY OF **ARCHITECTURE** AT WARSAW UNIVERSITY OF TECHNOLOGY AND STARTED MY OWN BUSINESS AFTER SCHOOL. I WORK AS AN ARCHITECT, WATERCOLORIST AND FREELANCE **ILLUSTRATOR** AND I WORK WITH COMPANIES AND INDIVIDUALS FROM ALL AROUND THE WORLD.

MAJAWRONSKA.COM

WATERCOLORS, BRUSHES

WHY DO YOU KEEP A SKETCH JOURNAL?

After all these years of permanent drawing and painting, it's easier to put
down some thoughts in drawings than in words, so I keep a sketch journal.
I draw memos to the people closest to me. I like sketching so I don't want to
stop doing it – it's just a part of my everyday life...

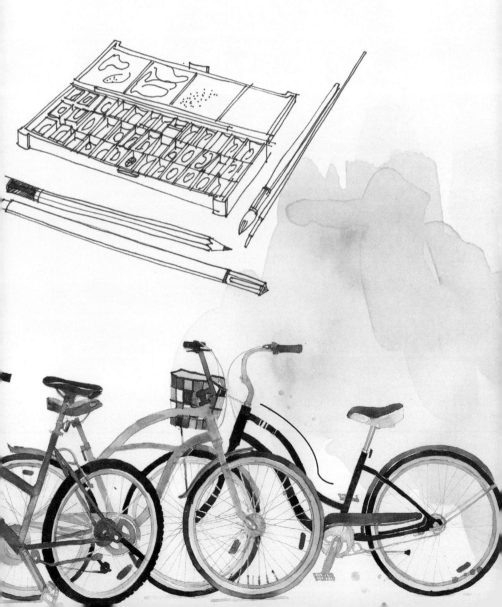

Different Watercolor effects

Splashing

When you have no idea how to end your painting, or want to add a random look to your artwork, try mixing some watercolor with water and sprinkling it on your work. This way you can create attractive and fascinating stains.

Leave white spots

White watercolors don't work like other colors - you can't cover something in white. So if you want to create depth or details while painting, you don't have to paint the whole canvas. Try leaving some areas unpainted, using the white canvas as an additional color.▷ ▷

Draw with the brush

Instead of painting with a huge amount of water, you can try using a little water with a lot of pigment. This will allow you to draw with the watercolors just like with markers - except you can still mix the colored strokes you make.

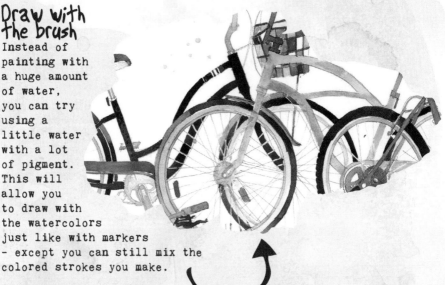

Smooth color mixing

When you paint with two very wet colors next to each other, you'll see them mix and stain together. This effect is unpredictable but that shouldn't stop you from trying it. It's really ◀◀ fun!

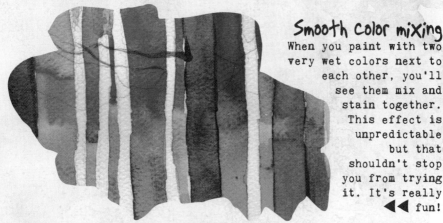

Tip!

The beauty of watercolor comes from the fact that it's a bit unpredictable. It's almost impossible to create two pieces exactly the same. However, if you're patient and aware of this element, you can easily create a vibrant and sophisticated painting. You can paint light and delicate works or dark and heavy pieces, depending on the proportion of water and pigment you use.

Sketching textures

CONSTANT THICKNESS

If you're tired of changing the thickness of lines (which demands more strength in your hand), you can create a whole drawing with the same thickness of line. The lines should be most concentrated in the key areas of your drawing, fading away in the direction of the paper's borders.

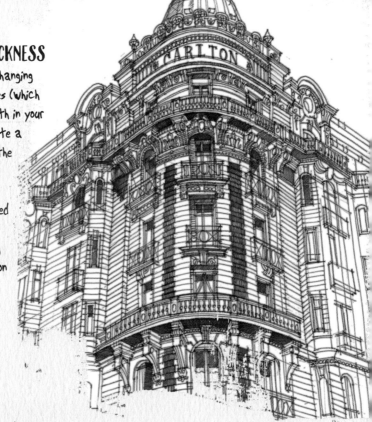

TIP! Pencil and pen are perfect tools that can be used for almost every type of illustration. Pencils are good for doodles, everyday sketching, technical drawings, and realistic (even photorealistic) depictions. Pens and markers are cleaner and more precise, a better choice for architectural sketching.

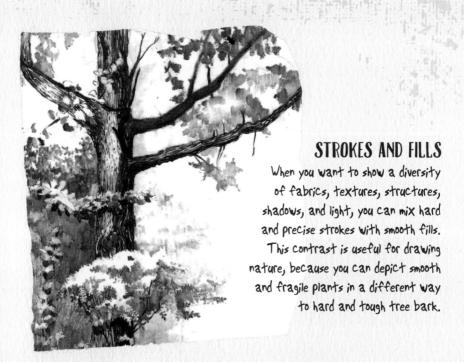

STROKES AND FILLS

When you want to show a diversity of fabrics, textures, structures, shadows, and light, you can mix hard and precise strokes with smooth fills. This contrast is useful for drawing nature, because you can depict smooth and fragile plants in a different way to hard and tough tree bark.

SOLID COLOR

You can digitize a traditional drawing by scanning it or taking a photo, then re-draw it or change its color on the computer. This way you can obtain a solid, flat color which is difficult to obtain with traditional techniques. Using a paint bucket tool in software like GIMP or Photoshop ensures you have the exact same color in the whole area.

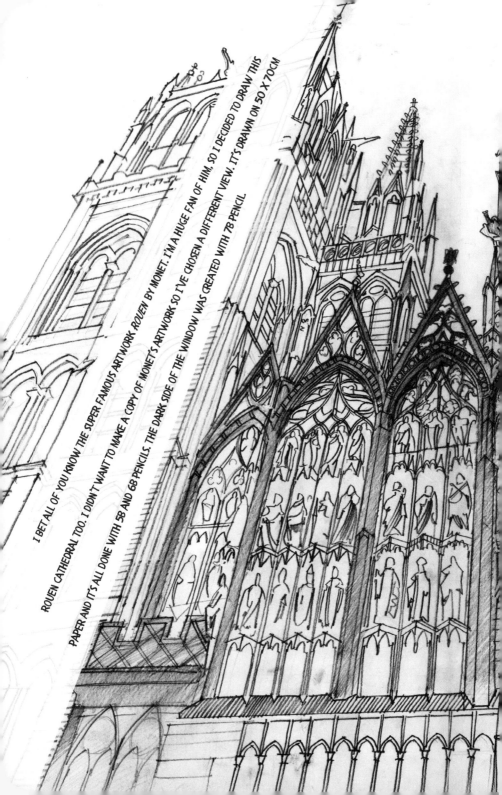

I BET ALL OF YOU KNOW THE SUPER FAMOUS ARTWORK ROUEN BY MONET. I'M A HUGE FAN OF HIM, SO I DECIDED TO DRAW THIS ROUEN CATHEDRAL TOO. I DIDN'T WANT TO MAKE A COPY OF MONET'S ARTWORK SO I'VE CHOSEN A DIFFERENT VIEW. IT'S DRAWN ON 50 X 70CM PAPER AND IT'S ALL DONE WITH 5B AND 6B PENCILS. THE DARK SIDE OF THE WINDOW WAS CREATED WITH 7B PENCIL.

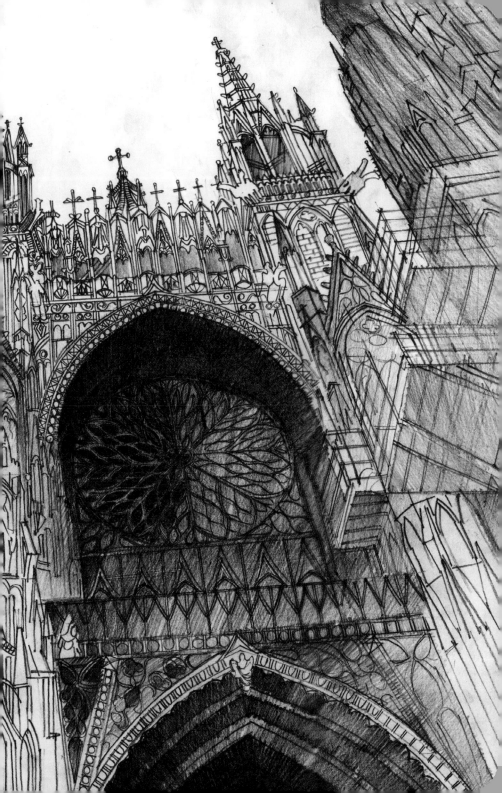

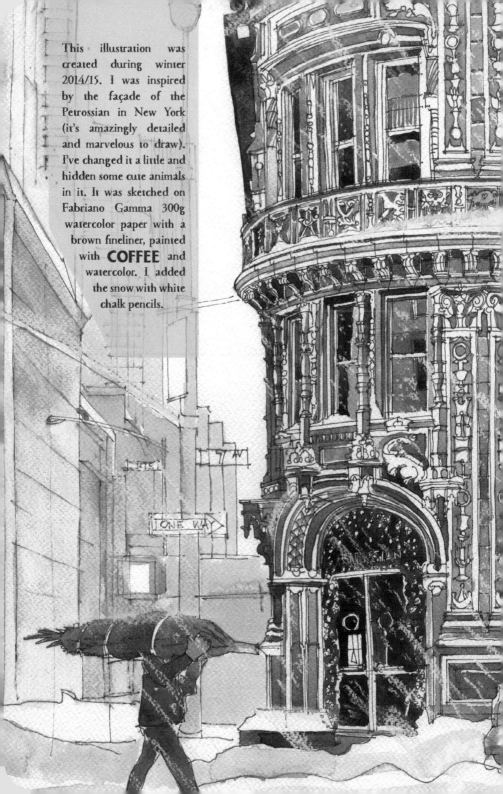

This illustration was created during winter 2014/15. I was inspired by the façade of the Petrossian in New York (it's amazingly detailed and marvelous to draw). I've changed it a little and hidden some cute animals in it. It was sketched on Fabriano Gamma 300g watercolor paper with a brown fineliner, painted with **COFFEE** and watercolor. I added the snow with white chalk pencils.

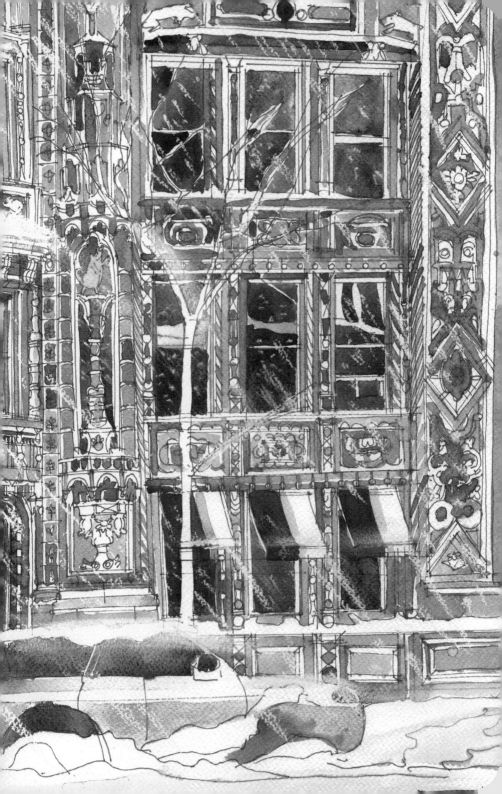

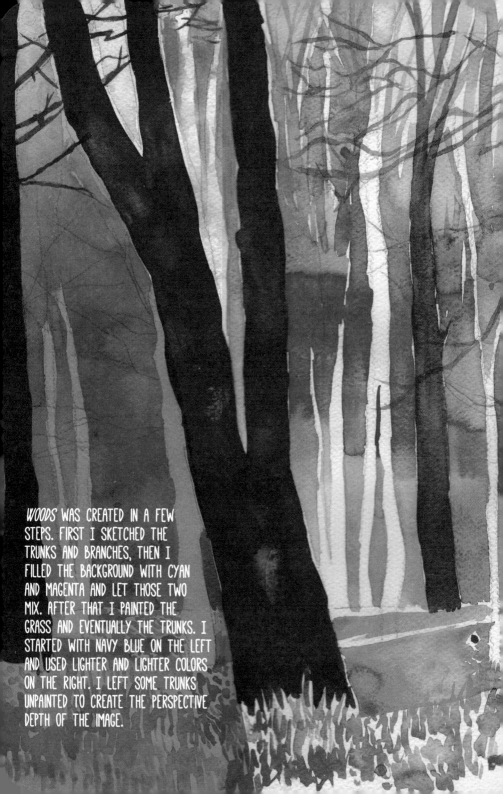

WOODS WAS CREATED IN A FEW STEPS. FIRST I SKETCHED THE TRUNKS AND BRANCHES, THEN I FILLED THE BACKGROUND WITH CYAN AND MAGENTA AND LET THOSE TWO MIX. AFTER THAT I PAINTED THE GRASS AND EVENTUALLY THE TRUNKS. I STARTED WITH NAVY BLUE ON THE LEFT AND USED LIGHTER AND LIGHTER COLORS ON THE RIGHT. I LEFT SOME TRUNKS UNPAINTED TO CREATE THE PERSPECTIVE DEPTH OF THE IMAGE.

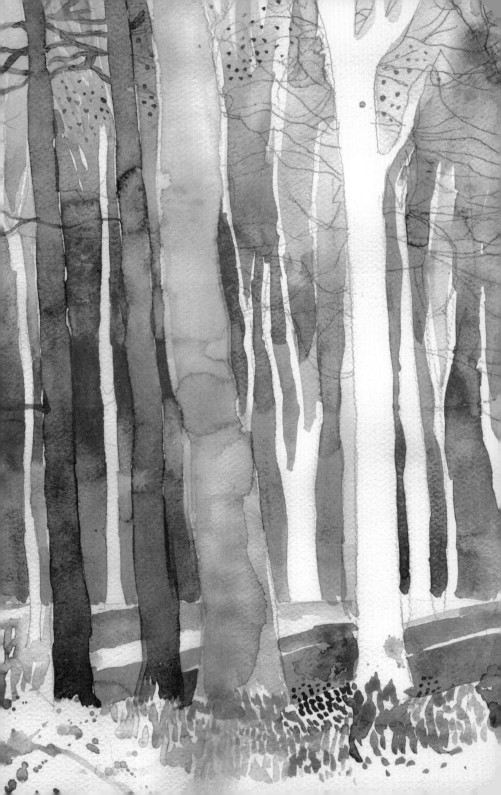

What advice would you give to someone who's just getting into sketching?

The first rule is to appreciate what you do. If you're really into sketching, you should just do it and practice, practice, and practice. People who are just getting into sketching shouldn't worry about being judged. You can listen to some feedback from reliable sources, but keep in mind the goal you want to achieve - if it's just to be good at sketching, then practicing it is the best way.

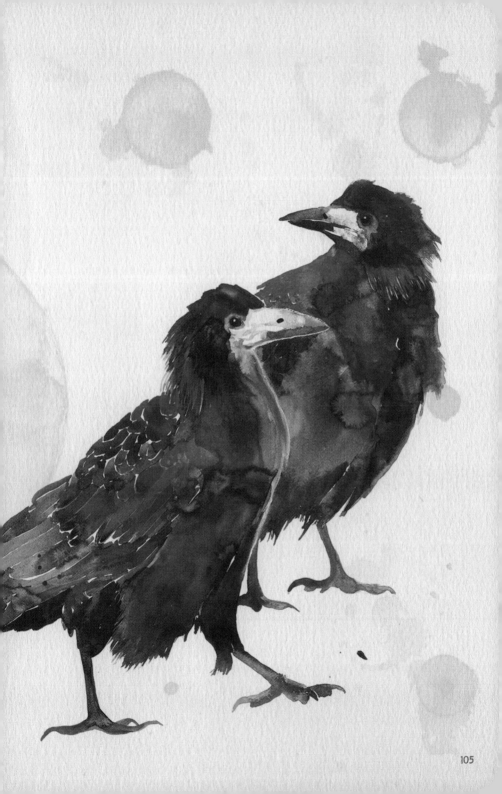

CHALLENGES AND IDEAS

If you're struggling to break in a new journal, or are just having a bit of a blank day, here are some challenges to get you sketching!

DAY 1. Draw a self-portrait with your non-dominant hand. (It doesn't matter if it's wonky then!)

DAY 2. Sketch your workspace, trying to include as many objects as you can.

DAY 3. Draw a picture using a single unbroken line - don't lift your pen or pencil from the paper!

DAY 4. Use at least three different materials or tools on one page.

DAY 5. Create an improvised drawing
or painting tool from something you have
lying around. Use it on today's page.

DAY 6. Cover the
page completely.

DAY 7. Incorporate a found object into
the page. A leaf, a ticket stub, a piece of
string... it could be anything!

OTHER THINGS TO TRY:

* DRAW WITHOUT LOOKING AT THE PAPER (BLIND CONTOUR DRAWING) OR WITH YOUR EYES SHUT. IT'S A GREAT WARM-UP EXERCISE AND YOU MIGHT BE SURPRISED BY HOW COOL AND FUNNY THE RESULTS ARE!

* SKETCH STILLS FROM YOUR FAVORITE FILM OR TV SHOW TO HELP STUDY TONE AND COMPOSITION. IT HELPS TO LEARN FROM OTHER MEDIA THAT YOU ENJOY.

* DRAW SOMETHING YOU'VE NEVER DRAWN BEFORE. MAYBE IT'S A WEIRD FISH, A TYPE OF VEHICLE, AN UNFAMILIAR ANIMAL; MAYBE IT'S SOMETHING YOU'VE PUT OFF LEARNING BECAUSE IT DOESN'T SEEM FUN. LOOK UP REFERENCE IMAGES AND INTERESTING ARTICLES UNTIL SOMETHING CAPTURES YOUR IMAGINATION. THERE'S NEVER NOTHING TO DRAW.

* IF YOU'RE STUCK INDOORS OR CAN'T TRAVEL, USE GOOGLE STREET VIEW TO SEE OTHER PLACES-UP CLOSE. YOU CAN SKETCH EPIC VISTAS AND LANDSCAPES, OR TOUR AROUND THE SIDE-STREETS OF A DISTANT CITY!

DOODLES & SKETCHES

THIS IS YOUR CHANCE TO GET CREATIVE!

In each book of the *Sketching from the Imagination* series, 50 talented traditional and digital artists have been chosen to share their sketchbooks and explain the reasons behind their design decisions. Visually stunning collections packed full of useful tips, these books offer inspiration for everyone.

Sketching from the imagination

Sketching from the Imagination:An Insight into Creative Drawing

Sketching from the Imagination:Fantasy

Sketching from the Imagination:Sci-fi

Available from shop.3dtotal.com

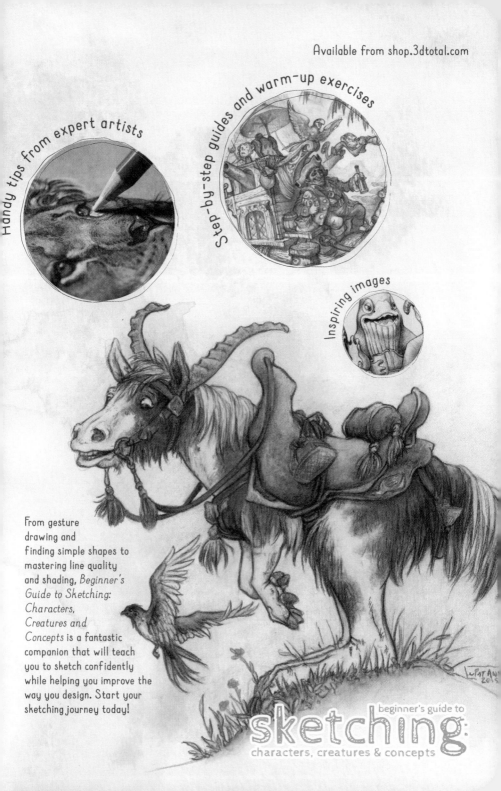